POSTCARD HISTORY SERIES

The Outer Banks

IN VINTAGE POSTCARDS

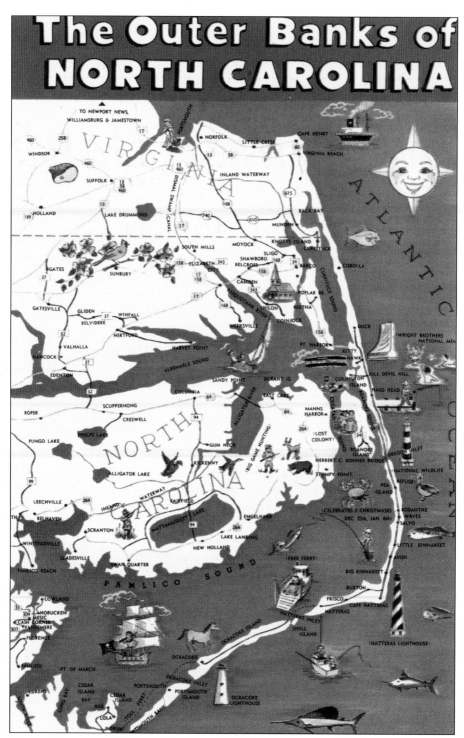

THE OUTER BANKS OF NORTH CAROLINA. If this map were to scale, the Outer Banks would be but a tiny sliver of white running down the upper coast of North Carolina from Virginia. (From the collections of the Outer Banks History Center, *c.* 1960.)

POSTCARD HISTORY SERIES

The Outer Banks

IN VINTAGE POSTCARDS

*Chris Kidder in cooperation with
the Outer Banks History Center Associates*

ARCADIA

Published by Arcadia Publishing
Charleston SC, Chicago IL, Portsmouth NH, San Francisco CA

Printed in Great Britain

Library of Congress Catalog Card Number: 2004117374

For all general information contact Arcadia Publishing at:
Telephone 843-853-2070
Fax 843-853-0044
E-mail sales@arcadiapublishing.com
For customer service and orders:
Toll-Free 1-888-313-2665

Visit us on the internet at http://www.arcadiapublishing.com

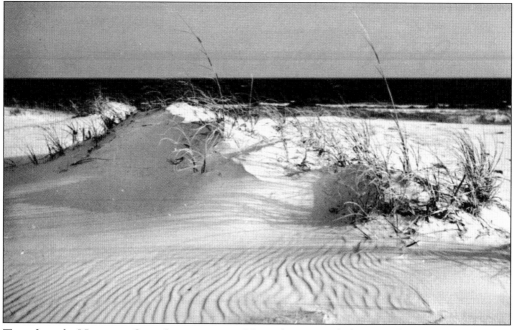

THE AREA'S NUMBER ONE ATTRACTION. Natural, uncrowded, serene beach scenes like this are what draw visitors to the Outer Banks. More than 70 miles of such beach were protected from development by the creation of the Cape Hatteras National Seashore. (From the collections of the Outer Banks History Center, *c.* 1965.)

CONTENTS

ACKNOWLEDGMENTS

On behalf of the Outer Banks History Center Associates and staff, I extend a hearty "Thank-you!" to Hank Frazier of Southern Shores. This project was his brainchild, modeled after a similar project he coordinated in his former home of Suffolk, Virginia. It was his desire that a portion of the proceeds be donated to the Outer Banks History Center. We did little more than we would do for any researcher or research project but will reap many rewards.

This is a work that is long overdue and I cannot imagine a better person to have authored it. Chris Kidder is the consummate researcher and she has been a delight to collaborate with on this project. In some cases, her inquisitiveness and persistence have precipitated more questions than answers, but we caretakers of history welcome such adventures. Chris is a talented writer, blending meticulous attention to historical detail with colorful description.

Images are always effective portals to the past. In a region where relatively little documentary evidence survives, each image is priceless. Seeing how things used to be is also a reminder that everything that surrounds us today will be history at some point in the future. In addition to marvelous images, this work is rich with little-known facts and fresh perspectives, which makes it equally suited for casual grazing or savoring every bite. I suspect it will quickly become a popular introduction to the history of our region.

KaeLi Spiers
Curator, Outer Banks History Center

My thanks, also, to Hank Frazier, a collector of postcards who saw the value in using those printed images to tell an interesting story. He showed the History Center's staff and the Associates' board of directors that the book could be done, recruited me to write it, and provided encouragement throughout its production.

Two other collectors of postcards—Michael G. Tames, Manteo, and Willard E. Jones, Ahoskie—shared their collections with me, allowing me to use cards from their collections to fill the visual gaps in the Outer Banks story I wanted to tell.

David Stick spent hours with me and on his own making sure I got the story right. The Outer Banks History Center, the repository of his personal collection of research materials, is a wonderful resource, but nothing matches sitting down with him and hearing the stories of how the Outer Banks became the place it is today.

Steve Brumfield, Danny Couch, H.A. Creef, Jeff DeBlieu, Sarah Downing, Bill Harris, Joe Malat, Earl O'Neal, and Barbara Snowden each invested time and shared their knowledge of the Outer Banks on this project. Dozens of others provided key pieces of information.

And, of course, the book couldn't have been done without the help of KaeLi Spiers, Kelly Grimm, and other staff and volunteers at the Outer Banks History Center.

Thanks to every one.

Note: Postcards in this book are dated, as best as can be determined, by their publication date or by postmarks. When a photograph is known to be significantly older than the card, that date is noted in the caption.

Chris Kidder

INTRODUCTION

The Outer Banks of North Carolina, a chain of barrier islands stretching from the Virginia border south around the bend of Cape Hatteras and west toward Portsmouth Island, is one of the world's most memorable vacation places. First-time visitors want to come back; repeat visitors want to find ways to return more frequently.

The islands' appeal is nothing new. Long before the English first landed to take a close look, Native Americans used the islands for hunting and fishing; some tribes lived here at least part of the year. Their history on the Outer Banks is largely undocumented except through the eyes of English explorers.

Philip Amadas and Arthur Barlowe led the first English expedition to the Outer Banks in 1584. The trip was financed by Sir Walter Raleigh, whose goal was to establish an English colony on the North American continent. Most likely, their exact destination was chosen by their pilot, Simon Fernandes (some historians refer to him as Simon Fernando), who claimed to have sailed in the area years earlier under a Spanish flag.

Barlowe's observations of the Outer Banks are assumed to have been written shortly after his arrival. Historian David Beers Quinn suggests that the account may have been "heightened by Ralegh's [sic] hand" before publication.

"We viewed the land about us." Barlowe enthused. "We found such plenty, as well here as in all places else . . . that I think in all the world the like abundance is not to be found." The "goodly woods" were full of deer, hares, fowl, and the "highest and reddest cedars of the world." The exact location of his landing is disputed; some reports place him on Ocracoke Island, while others place him at the north tip of what was then called Hatorask, on today's Hatteras Island, or at Trinity Harbor, north of Kitty Hawk Bay.

Barlowe and his men were "entertained with all love and kindness" by the "gentle, loving, faithful" Algonquin Indians, his account went on, making the Outer Banks sound like an Eden of biblical perfection. It's no wonder that hundreds of Raleigh's fellow countrymen volunteered to colonize this New World.

Unfortunately, as the colonists quickly discovered, the land did not provide a sustaining bounty of food. Nor were the natives so guileless as to sacrifice their own well-being for English colonists, who insisted that their Queen, the big chief Elizabeth, now owned the land. The colony failed.

Three hundred years later, another man looking for a destination made Outer Banks history. Wilbur Wright wrote to government weather stations at several East Coast locations in the summer of 1900. He needed a place with a lot of sand. A couple good-sized sand hills would be nice, he allowed, and he needed a large flat area free of trees. Dependable wind of 14 or 15 miles per hour and moderate weather were among his other requirements.

Wilbur's letter ended up in the hands of William Tate, who responded in mid-August. Tate's original letter was not kept, but in a later reconstruction he recalled telling Wilbur: "You would find here nearly any type of ground you could wish. . . . This in my opinion would be a fine place; our winds are always steady, generally from 10 to 20 miles. . . . Climate healthy. . . . You will find a hospitable people when you come among us."

Since it seems no one from any other location responded, Tate's letter was all the more convincing. Two weeks later, Wilbur left Dayton for Kitty Hawk. Tate's assessment of weather

conditions turned out to be useless: Storms and unreliable winds dogged Wilbur and his brother, Orville, during every visit.

Even so, the Wrights never regretted choosing the Outer Banks. In this respect, they were no different from Amadas, Barlowe, and thousands of others who came to the Outer Banks for one reason and found a dozen more to bring them back.

Some of those reasons have been documented over the last century in postcards. The earliest cards were probably print-on-demand cards taken and sold by traveling photographers. Soon, printers began producing cards that promoted steamships, hotels, and other businesses, along with stock photographs of everyday scenes that visitors and locals might want to share with family and friends in other places.

What images were included and what images were left out by the makers of postcards (with one exception, this book includes only cards originally published between 1900 and 1980) sheds light on how visitors have viewed the Outer Banks over the years. It's as much a part of the story as the recitation of facts.

The early facts accepted by most scientists are simple enough. The Outer Banks have existed in some form for about 15,000 years. When Raleigh's expeditions arrived, Algonquin Indians had been living on the coast of North Carolina for nearly 1,000 years and probably used the barrier islands as hunting and fishing grounds during some, if not most, of that time. Most of the natives were killed off in inter-tribal wars and with diseases contracted through exposure with Europeans.

When European settlers returned to the area in the 1600s, some natives were still hunting and fishing on the barrier islands, most notably the Hatteras tribe on the southern banks and Poteskeet tribe on the Currituck Banks. The first settlers, like most frontiersmen, were a motley lot. Raising livestock, whaling, and staying clear of Colonial authorities were the main occupations. In 1663, King Charles II included the islands in a land deal he made with eight Lords Proprietors, who immediately named their new property Carolina in his honor.

At the time of the American Revolution, the Outer Banks were sparsely populated and too remote to be involved in national politics. However, Ocracoke's inlet was a crucial supply source for American troops, as the British overlooked the isolated island while blockading the colonies' better-known ports.

Over the next 100 years, life would change with the establishment of the U.S. Lighthouse Board and Life-Saving Service and the development of commercial fishing. It would take the next century for the Outer Banks to become the place of postcards sent with scrawled messages: "We're having fun. Wish you were here."

One

THE SHAPE OF THE OUTER BANKS

The Outer Banks are part of a coastal chain of submerged sand ridges created thousands of years ago at the mouths of coastal rivers. Of all the barrier islands that front the Atlantic shoreline, the Outer Banks are unique. Where most barrier islands hug the mainland, the Outer Banks elbow east, out into the Atlantic, creating an estuarine system matched in size on the East Coast only by the Chesapeake Bay. Its largest component, the Pamlico Sound, is a lagoon so vast that early explorers believed it was the ocean leading to the Far East.

It should be noted that Roanoke Island is included in this book but is not a true barrier island, lying as it does between the Outer Banks and the mainland. Its topography and vacation appeal are different from the beach islands, but their history and future are inseparable.

Many writers have characterized the Outer Banks as ribbons of sand, and indeed, viewed from the air, that is exactly how they appear: thin strips of something less substantial than rock, lying end to end, floating across a sea of Atlantic blue.

While sand is the primary component of a barrier island, the islands that comprise the Outer Banks are more than sand beaches. The sound side of the islands is marsh, a nursery to the marine life that populates the surrounding waters and a feeding ground for thousands of birds that migrate along the Atlantic Flyway each year. Until the last century, there were thousands of acres of maritime forest between the marsh and natural dune ridges that form behind the beach along wider stretches of island. These forests are now mostly gone. Only remnants of the complete ecosystem remain in Buxton Woods, Kitty Hawk Woods, and Nags Head Woods.

Jockey's Ridge itself is one of the Outer Banks' few natural landmarks: a medano—a large, unvegetated, migrating dune—once the largest on the East Coast. Unstable by its very nature, it is constantly redistributed, reshaped, and resized by wind. Until recently, the dune moved steadily one to two feet to the southwest each year, while the height and size of its field remained fairly stable.

Today, nothing stops sand from blowing off the dune's top, but human additions to the landscape interfere with the replenishment process. Consequently, the height of the dune is shrinking, from nearly 140 feet in 1900 to 110 feet in 1980 to under 90 feet in the early 1990s.

Like Jockey's Ridge, the barrier islands respond to natural forces, migrating with wind and wave, recreating themselves over and over again, far less fragile than their description as ribbons of sand suggests.

From the time it began forming after the end of the last ice age, the entire barrier island chain has been moving. It is only in relation to manmade structures—buildings and roads in particular—that this natural movement began to be viewed as undesirable.

Shoreline erosion is now viewed as a problem to be solved rather than part of a natural process to protect the island's equilibrium. The solutions have affected nearly every natural aspect of the islands. The beach, the marsh, and the native flora and fauna are all at risk of changing in ways that many may find less appealing.

Arguably, the effects of most human interference are subtle, especially in the short term. But there is little question that were Sir Walter Raleigh's men or the Wright brothers to return to the Outer Banks today, they would not recognize the place.

Many of the most visible changes to the Outer Banks over the past four centuries were brought about by storms opening and closing inlets in the barrier island chain, but the biggest changes have been strictly man's doing, as humans have tried to take control over the last 75 years. They fill in new inlets as soon as they open and pump sand out of old ones that want to close. They build dunes where natural processes have built a flat beach. With every storm tide, nature picks away at them as if these artificial dunes were burrs in her side. Along some stretches of beach, dunes are rebuilt several times a year. It is a contest of wills that some believe nature is winning.

The infrastructure of contemporary culture has changed the barrier islands from isolated outposts to accessible vacation resorts. Whether one sees these changes as necessary steps to maximize the enjoyment of natural resources or the short-sighted destruction of those same resources, it is good to keep in mind that these changes are no more permanent than the islands themselves. In less than a lifetime, most of what's been built here today will have vanished, victims of architectural trends, economics, lifestyle preferences, and, as always, nature.

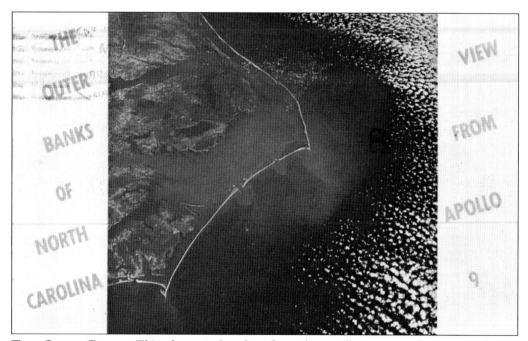

THE OUTER BANKS. This photograph, taken from the *Apollo 9* spacecraft, puts the barrier islands in perspective. The 120 miles of beach visually fills its billing as ribbons of sand, streaming into the Atlantic from its tenuous connection to the Virginia mainland. The image retains its interest more than 30 years after it was taken. (From the collections of the Outer Banks History Center, 1969.)

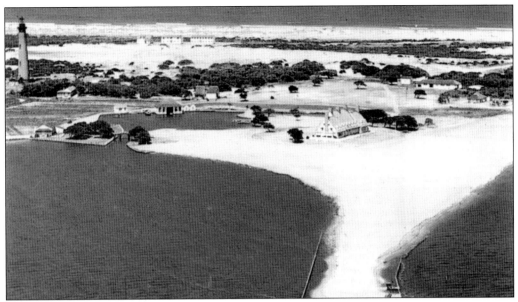

COROLLA. This Currituck Banks village was a popular duck-hunting destination for wealthy businessmen in the early 20th century. By World War II, the sporting life had lost its hold on America's upper class, and the area was not again considered a tourist destination until a paved road to Corolla opened in 1985. The Whalehead Club is in the foreground; Currituck Beach Lighthouse is to the left. (Courtesy of Michael G. Tames, *c.* 1955.)

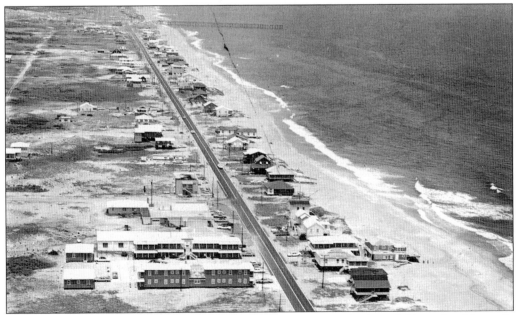

KITTY HAWK. Originally the village was nestled north of a wide dune field on the Albemarle Sound. Oceanfront development of vacation homes began in the 1930s and was well underway when this photograph was taken in the 1950s looking north at the Kitty Hawk Pier. By the end of the 1990s, most homes on this stretch of beach had been damaged or destroyed by storms and high tides. (Courtesy of Michael G. Tames, 1977.)

NAGS HEAD, N.C.

KILL DEVIL HILLS. The islands are composed of several microclimates, each with distinctive features. Areas open to salt air and persistent wind are inhospitable landscapes for most plants. Live oak, yaupon, and the few other trees able to grow in this zone are often stunted and bent in the direction of the prevailing wind, as shown in this photo, probably taken near Run Hill on Buzzard Bay, not in Nags Head as the inscription indicates. (Courtesy of Willard E. Jones, 1911.)

NAGS HEAD WOODS. Wide sections of barrier islands often develop dune ridges that shelter biologically diverse maritime forests unable to survive in salt air. These ecosystems differ greatly from the nearby beach. North of Jockey's Ridge, this area, with its freshwater ponds, still supports southern red oaks, beech, and other deciduous hardwoods and attracts more than 50 species of birds not found on the beach. (Courtesy of Willard E. Jones, c. 1920.)

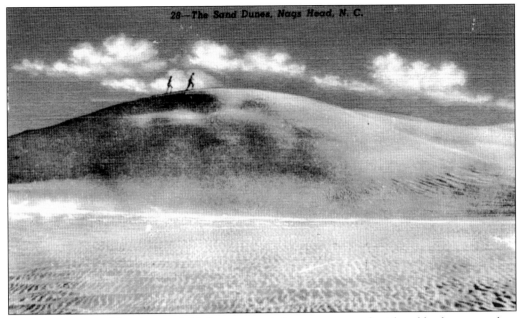

JOCKEY'S RIDGE. The slopes of this large natural dune are covered with ankle-deep, powdery sand, while its top can seem as hard as a sidewalk. The top layer of sand absorbs heat, often becoming 20 or 30 degrees warmer than air temperature. But just inches below the surface, sand can be 20 or 30 degrees cooler than the air. (From the collections of the Outer Banks History Center, 1953.)

JOCKEY'S RIDGE. Outer Banks sand contains quartz and traces of garnet, tourmaline, topaz, and other rock-forming minerals. In the geologic scheme of things, sand is adolescent rock on its way to becoming silt. Its age is measured in millennia, not years. The dune may be only 5,000 years old—a mere blink of the eye in geological time—but its sand is probably three times that age. (From the collections of the Outer Banks History Center, c. 1950.)

COLINGTON ISLAND. This property was deeded to John Colleton in 1663 by the Lords Proprietors, making it the first privately owned land on the Outer Banks. West of Kill Devil Hills, it forms the southern shoreline of Kitty Hawk Bay. Colington's steep, forested sand hills have sheltered generations of crabbers and fishermen who made their living in the surrounding waters. (Courtesy of Michael G. Tames, 1961.)

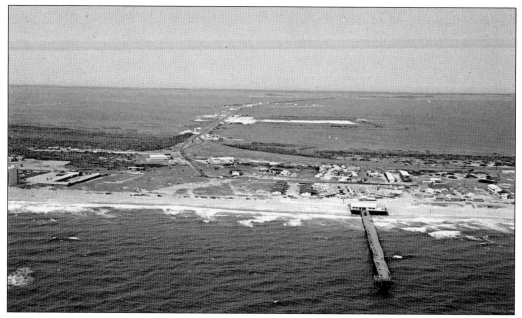

WHALEBONE JUNCTION. The narrowest section of Nags Head lies at this intersection of highways, where tidal shoals were filled in the 1920s to create a causeway for a bridge linking the beach to Roanoke Island. It was named for a whale skeleton displayed at a gas station here in the 1930s. Jennette's Pier is in the foreground. (Courtesy of Willard E. Jones, c. 1960.)

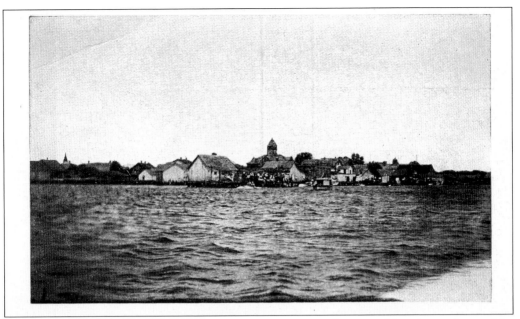

MANTEO. The town was made county seat in 1870 because of its central location and accessible, protected harbor on Shallowbag Bay. Until well into the mid-1900s, the preferred transportation for locals continued to be the boat, and the town's businesses remained clustered on the waterfront, as they were when this photograph was taken in the early 1900s. (Courtesy of Michael G. Tames, *c.* 1915.)

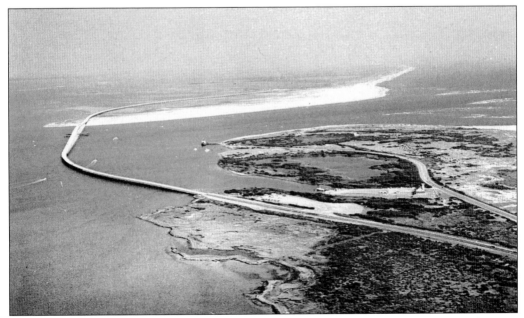

OREGON INLET. Opened during a hurricane in 1846, the inlet has migrated steadily south. Since this photograph was taken, looking north toward Nags Head shortly after the Herbert C. Bonner Bridge was built, the sand-beach shoreline on the north side of the bridge has been replaced by tidal shoals and marsh. (From the collections of the Outer Banks History Center, *c.* 1963.)

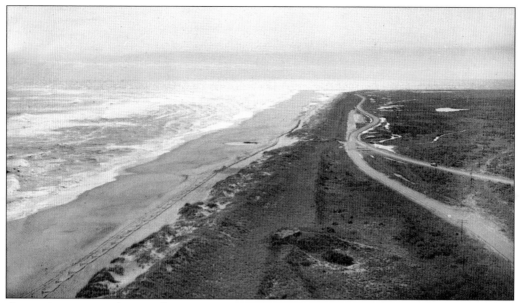

CAPE HATTERAS. The cape lies near Buxton on Hatteras Island. This turbulent corner, where northern currents flowing south and the Gulf Stream flowing north collide, kicking up a fuss and building ship-eating shoals, is one of the most treacherous points on the North Carolina coast. This photograph was taken from the top of the Cape Hatteras Lighthouse before it was moved. (From the collections of the Outer Banks History Center, 1961.)

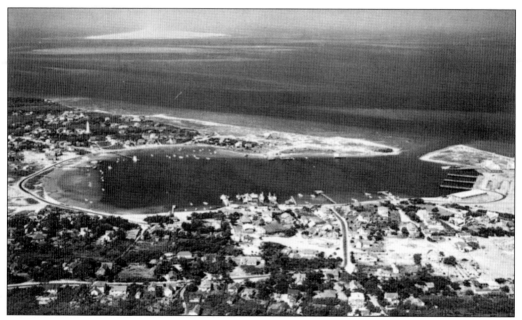

OCRACOKE VILLAGE. The village on Silver Lake at the island's southwest end is the only developed area on Ocracoke Island. The lake, formerly Cockle Creek, was dredged in 1931. Except for the village, the entire 16-mile-long island is part of the Cape Hatteras National Seashore. Ocracoke Lighthouse is on the left. (Courtesy of Hugh Morton, from the collections of the Outer Banks History Center, c. 1955.)

Two
NATURE'S BOUNTY

What the Outer Banks has lacked in accessibility, it has always made up for in the abundance of its natural resources. The first reports of the area, written by Amadas and Barlowe, described a supply of diverse waterfowl, fish, hare, and deer unmatched in Elizabethan England. Later visitors to the area were similarly impressed.

Fall and winter skies above the Outer Banks are filled with rafts of ducks following the Atlantic Flyway south. Canvasbacks, teals, buffleheads, mallards, pintails, ring-necks, scoters, mergansers, ruddies, and black ducks are joined by Canada and snow geese, black brant, and barnacle geese. They fill shallow, sheltered waterways and ponds along the inland shore. Some leave the flyway, wintering in the coastal marshlands.

Waterfowl are protected here, well-fed guests of the national wildlife refuges that encompass large tracts of the soundside landscape. It was not always so. Starting in the 1870s, gun clubs dotted the Outer Banks, inshore islands, and the nearby mainland. Every hummock of marsh grass with access to the water, or so it seemed, had an outpost where the upper crust of America's industry and well-connected locals could prove their prowess with firearms.

Many of the gun clubs offered the comforts of home, including live-in caretakers, servants' quarters, parlors, formal dining rooms, heated bedrooms, and indoor plumbing. With the exception of the caretakers' families, these clubs were almost always all-male bastions of gentility.

By the early 1900s on Ocracoke, the men of almost every island family worked seasonally as hunting and fishing guides or as decoy carvers for the local clubs. Jack Dudley, in Wings: North Carolina Waterfowling Traditions, *called the island "a mecca for hunters and channel bass fishermen." Market hunting also provided seasonal income for locals until it became illegal in 1918.*

Waterfowl are still an economic boon to the area, only today's visitors come armed with cameras, viewing scopes, and birding books instead of guns.

Bounty from the skies has been matched by bounty from the sea. Early settlers fished to feed their families. Commercial fishing became important to the local economy after the Civil War, but by the end of World War II, its impact was lessened by the growth of real estate development and tourism. In the 19th and early 20th centuries, many fishermen also worked for the U.S. Life-Saving Service, whose foul-weather business rarely coincided with good fishing. In a good year, even on a part-time basis, a fisherman could make a living from the sea.

Today, local commercial fisheries operate year-round, following the fish north and south when the seasons end here. Over the last 50 years, Wanchese has become the center of local commercial fishing, but nearly every Outer Banks harbor has a commercial fish house or two where fish can be bought fresh off the boat.

In the 1930s, powerboats gave rise to a different kind of fishing. Capt. Ernal Foster's Albatross Fleet at Hatteras was the first to make a business of fishing the Gulf Stream for sport. The offshore supply of tuna, dolphin, marlin, shark, and other trophy fish, including several record-setting catches, has been sufficient to keep a steady line of charter boats flowing through the area's three inlets from spring to fall.

The sport of fishing has changed, too. As fish stocks showed signs of over-fishing in the 1950s, size limits and catch-and-release programs were developed. In the past 30 years, catch-and-release has become the standard, not the exception, for trophy fish.

But, with some resources, there can be too much of a good thing. Conservationists have been working for over four decades to keep the barrier island's wild horse herds small enough to thrive in an environment that becomes less horse-friendly with each passing year.

No one knows exactly how or when the horses arrived. It is certain they are not native to the area. Most likely, beginning in the 1600s, horses—along with livestock of all description—were brought to the barrier islands, which, at that time, were privately owned. There were no natural predators and no need for fences. In the 1930s, construction of homes and roads made laws banning open grazing necessary, but isolated herds of horses remained on Ocracoke and the Currituck Banks.

In the 1950s, Ocracoke residents began trying to manage the island's herd, which at one time numbered more than 300. The National Park Service took over and thinned the herd in the early 1960s. Twenty-five to thirty ponies now live on 180 acres of soundside pasture. A few can almost always be seen at the pony pens between the Hatteras ferry dock and Ocracoke village.

Currituck's ponies roamed free until 1989, when the Corolla Wild Horse Fund moved the herd north of Corolla, away from landscaped houses and paved roads.

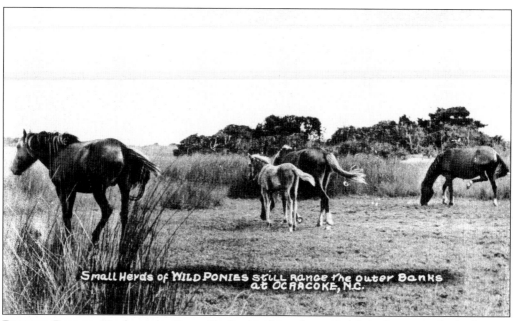

BANKER PONIES. Herds on the Outer Banks may have descended from horses washed ashore in shipwrecks or left behind by Spanish explorers in the 1600s. Farmers may have brought them to the islands 200 years later. In any case, in years past, they distinguished themselves as local celebrities and as working mounts. In the 1950s, Ocracoke Boy Scouts tamed ponies from the local herd, becoming the only mounted troop in the nation. (From the collections of the Outer Banks History Center, c. 1930.)

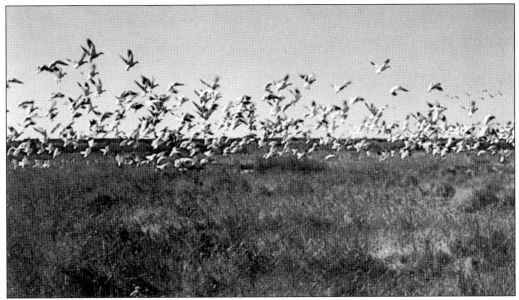

SNOW GEESE. Beginning each November, thousands of snow geese—along with about three dozen other species of waterfowl—arrive on the Outer Banks. They spend the winter feeding in the marshlands lining the Currituck, Roanoke, and Pamlico Sounds before heading back to their summer range on the islands of the Arctic Ocean. (From the collections of the Outer Banks History Center, 1963.)

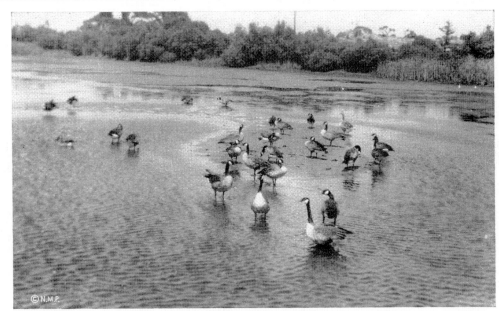

Winter Visitors, Kitty Hawk, N. C.

CANADA GEESE. Some of these large waterfowl like Pea Island so much that they stay on when the rest of the flock heads back to Canada and the extreme northern United States. Although the caption on this card says the picture is at Kitty Hawk, it was more likely taken on the Currituck Banks or near Bodie Island. (Courtesy of Michael G. Tames, *c.* 1930.)

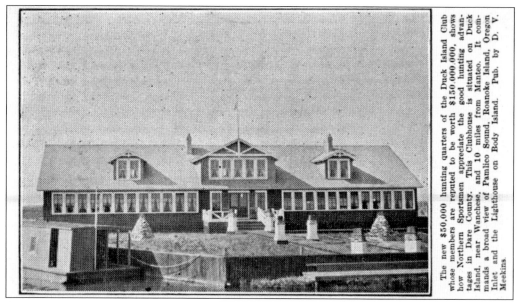

DUCK ISLAND CLUB. Gun clubs near Manteo and Bodie Island were not built until more than 20 years after the first clubs were built in Currituck. By the 1930s, Duck Island, owned by wealthy investors from Pittsburgh, was one of many in the area. The club, which at one time employed several local men and women as guides and cooks, still stands on its private island in Roanoke Sound, between Wanchese and Oregon Inlet. (Courtesy of Michael G. Tames, *c.* 1930.)

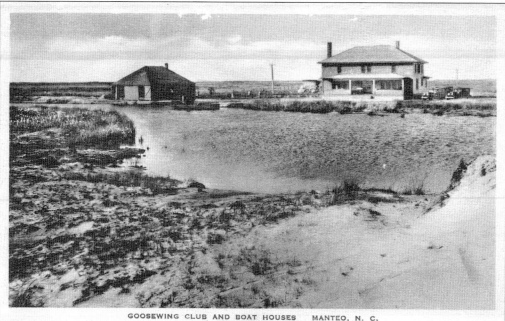

GOOSEWING CLUB AND BOAT HOUSES MANTEO, N. C.

GOOSEWING CLUB. The owner of the Goosewing, Jules Day, aimed to make the club as well known as gun clubs on the northern Currituck Banks. He purchased several hundred acres of land on Bodie Island and had shallow ponds dug in the marshes to attract waterfowl. (Courtesy of Willard E. Jones, 1932.)

20

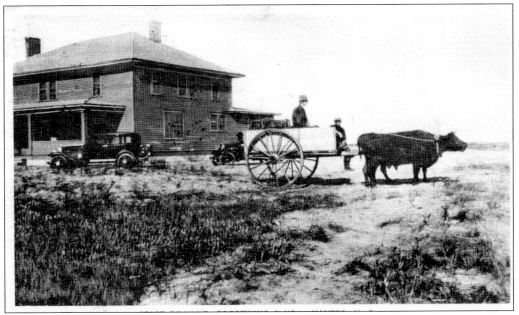

GOOSEWING CLUB. Many of the gun clubs in the Nags Head area were locally owned and modest enough to rightfully be called camps. The two-story Goosewing offered more luxurious accommodations, but nothing in this area compared to the three-story, 20-room Lighthouse Club in Corolla, with its corduroy-covered walls, Tiffany lights, and baby grand piano. (Courtesy of Willard E. Jones, 1932.)

GOOSEWING CLUB. Members of area hunt clubs did not limit themselves to waterfowl. Fox, the largest predator found on the barrier islands, was a prized catch. These hunters are probably holding gray fox, a species native to the area. Red fox, imported from England and well established in New England by the late 1880s, were not documented on the Outer Banks until much later. (From the collections of the Outer Banks History Center, *c.* 1932.)

SKYCO LODGE. Jules Day, owner of the Goosewing Club, purchased the old Ashby House at Skyco in the 1920s, named it Skyco Lodge, and used it as a hunting retreat. He later leased it as a family residence to Frank Stick in 1929. (From the collections of the Outer Banks History Center, *c.* 1925.)

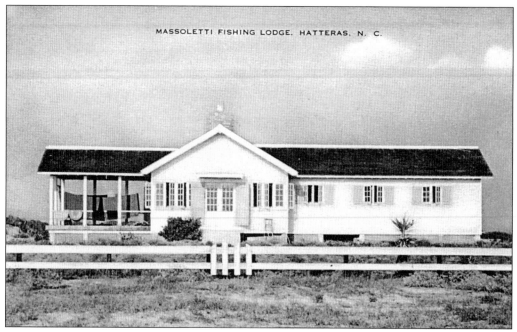

MASSOLETTI FISHING LODGE, HATTERAS, N. C.

MASSOLETTI FISHING LODGE. Fishing, not hunting, was what drew most sportsmen to Hatteras Island. New York restaurateur Joseph Massoletti entertained the Delmonicos and other famous guests at his lodge and aboard the *CoCo*—one of the first private yachts at Hatteras—when they fished for tarpon in the Gulf Stream. The lodge, located in Hatteras Village, is now a private residence. (Courtesy of Michael G. Tames, *c.* 1956.)

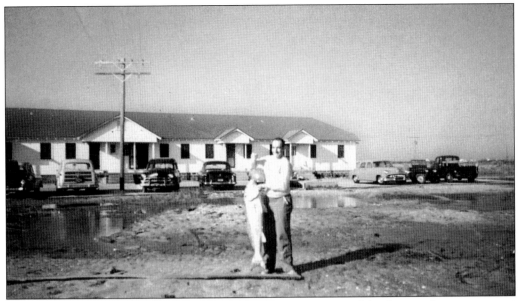

DURANT'S COTTAGES. Owned by Shank Austin, this was one of the first tourist motor courts to open in Hatteras Village, and fishing was the major attraction. This fisherman's catch fell short of the all-tackle, world-record red drum, which weighed 94 pounds and was caught in the surf at Avon in 1984. Hurricane Isabel destroyed the building in 2003. (From the collections of the Outer Banks History Center, *c.* 1955.)

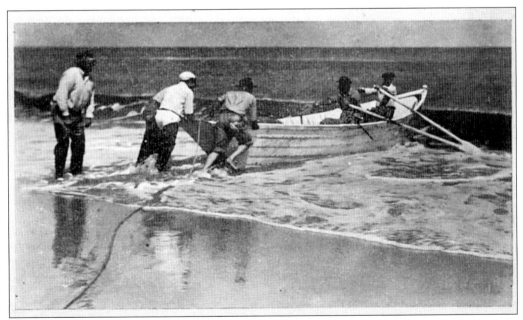

SETTING THE NETS. Fishermen launching their boats from Outer Banks beaches were once common sights during spring and fall. Boats were rowed through the breakers to encircle schools of bluefish, sea trout, grouper, mullet, spot, or croaker with seine nets. Motor-driven boats with power winches do the work now. Mullet is primarily a baitfish, but the rest, like most fish caught on the Outer Banks, were caught for eating. (Courtesy of Michael G. Tames, *c.* 1935.)

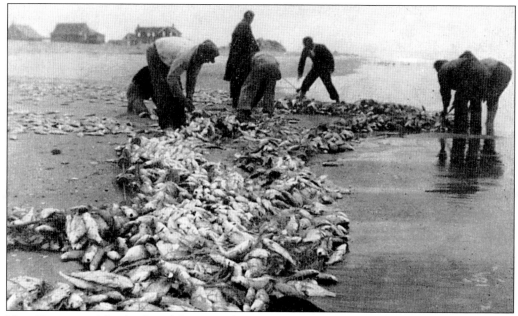

NET HAULING. After hauling full nets to the beach by hand, fishermen harvested their catch of spot. (From the collections of the Outer Banks History Center, *c.* 1935.)

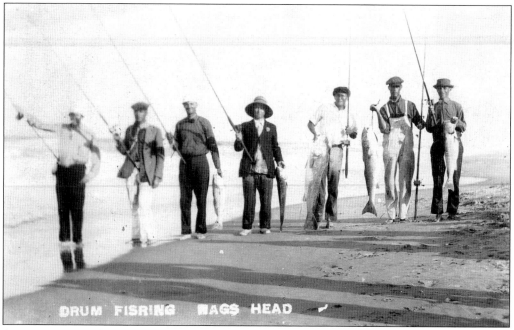

SURFCASTING. Fish that could be caught close to shore were also caught from the beach, at the piers, and in the sounds. These fishermen were catching red drum, also known as channel bass. (Courtesy of Willard E. Jones, *c.* 1935.)

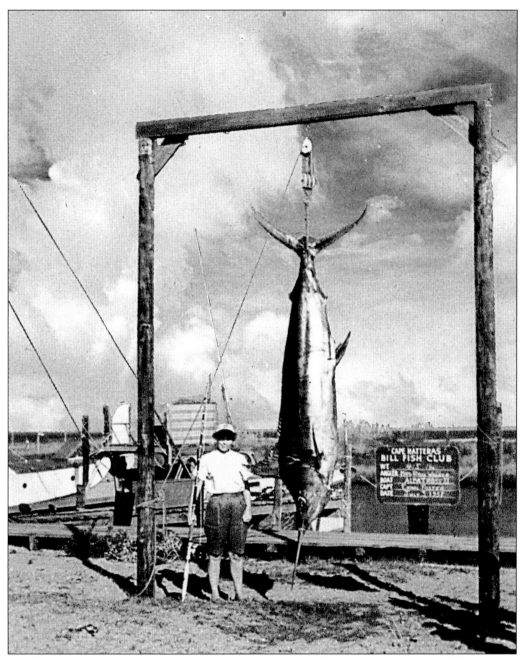

BLUE MARLIN. Marlin and other game fish are caught offshore in the Gulf Stream. This marlin, caught from the *Albatross II* out of Hatteras in July 1957, weighed 415 pounds. A world-record blue marlin weighing 1,142 pounds was taken by a boat out of Oregon Inlet Fishing Center in 1974. It still holds the North Carolina record. (From the collections of the Outer Banks History Center, 1957.)

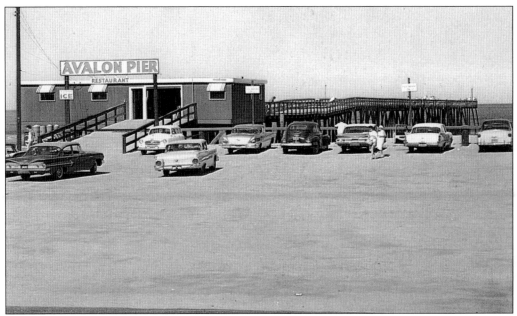

AVALON PIER. Named after the surrounding post–World War II real estate development in Kill Devil Hills, the pier's owners billed it as the "most modern fishing pier" when it opened in 1958. (Courtesy of Michael G. Tames, *c.* 1960.)

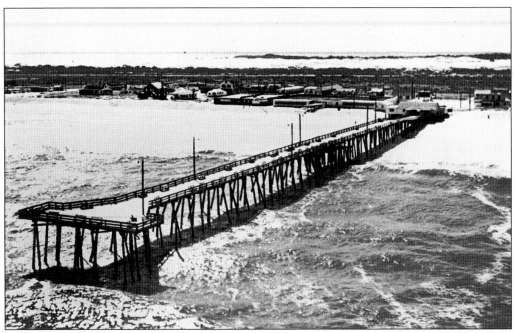

NAGS HEAD FISHING PIER. The opening of piers for fishing on the Outer Banks made it easier for fishermen to catch king mackerel, shark, and larger blues and drums, along with the mullet, spot, and croakers that could also be caught from the beach. Two sharks caught off Nags Head Pier in the 1960s still hold the state records. (From the collections of the Outer Banks History Center, *c.* 1955.)

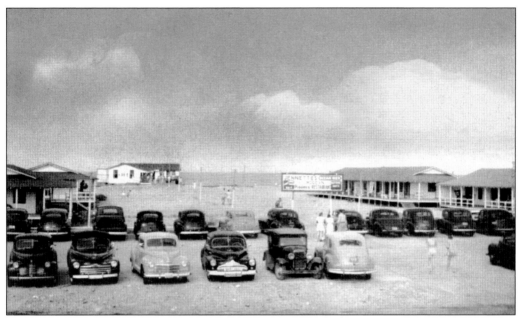

JENNETTE'S OCEAN PIER. The North Carolina Aquarium Society now owns the Outer Banks' oldest pier. When it was opened in 1939, the owners also offered rooms for rent next door. The cottages had been built a few years earlier as a camp for transient workers, under the auspices of the WPA. (From the collections of the Outer Banks History Center, *c.* 1950.)

OREGON INLET. Although the inlet has changed a great deal in the last 50 years, it remains a popular fishing spot. Because the water at the inlet is nearly as salty as the ocean, fishermen on the soundside, shown on this postcard, can catch the same fish caught from the ocean beach. (Courtesy of Michael G. Tames, 1957.)

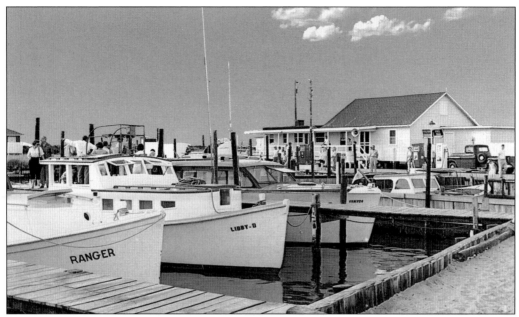

OREGON INLET FISHING CENTER. Opened in the 1960s within the boundaries of the Cape Hatteras National Seashore, this marina is home to a long roster of charter boats. It is the closest marina north of Hatteras to the Gulf Stream, where several record-setting fish have been caught, including a 300-pound bigeye tuna, which still holds the state all-tackle record. (Courtesy of Michael G. Tames, *c.* 1965.)

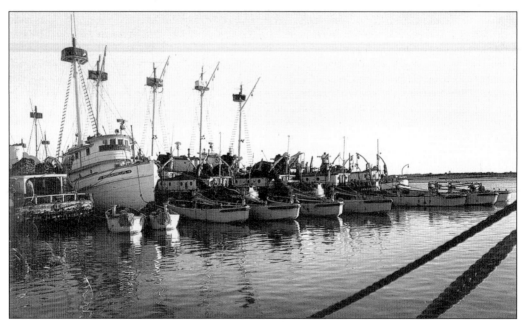

COMMERCIAL FLEET AT HATTERAS. Commercial fisheries, once larger contributors to the local economy, play an important role at Hatteras, Ocracoke, and Wanchese, where more than 40 trawlers still leave the docks to catch flounder and scallops or drop net for king mackerel, gray trout, croakers, and bluefish. (Courtesy of Michael G. Tames, 1963.)

Three

THE CURRITUCK BANKS

Because of the effects of geography, the history of people and place is different from one end of the Outer Banks to the other. The northern beaches of Currituck County were closest to the large population centers in Tidewater Virginia, but without a reliable navigable inlet in this section of the barrier chain to create jobs and encourage settlement, the area was more isolated and slower to develop than any other part of the Outer Banks.

The entire beach north of Bodie Island was once called Currituck Banks. New Currituck Inlet, just south of the Virginia border, and Caffey's Inlet, north of the village of Duck, both closed in the early 1800s. According to geologist Orrin Pilkey, these were the last in a string of 26 inlets that made islands of this stretch of sand during most of the last four centuries. The Currituck Banks are now a peninsula connected to the mainland of Virginia below Cape Henry at Virginia Beach.

Geologically speaking, the southern margin of this peninsula is at Oregon Inlet. Throughout the state's early history, the entire peninsula was called Currituck Banks because, until 1870, it was all part of Currituck County. Today, the section of beach described as Currituck Banks stops at the Dare County line just north of Duck.

Boundary changes are nothing new for the Outer Banks. North Carolina's barrier islands were initially part of England's Virginia—a paper empire that encompassed all land in North America claimed for the queen. In 1663, no doubt for economic reasons, the size of the royal colony of Virginia was greatly reduced. King Charles II drew a new east-west border that began below the mouth of the Chesapeake Bay and chartered all the land south of the border to a promising business venture run by eight Lords Proprietors.

At the time, the northern part of the Outer Banks began at the Currituck Inlet, which served as the coastal marker for the Virginia border, and may have extended as far south as present-day Nags Head. This 50-mile strip may have also been called Lucke (or Lucks) Island but not for long. Several inlets opened in the 1700s, reconfiguring the landscape.

In the late 1500s, when English explorers first came to the Outer Banks, the northern beaches were being used as hunting and fishing grounds by Poteskeet Indians from the mainland. When colonists began settling the mainland of what is now Currituck County at the end of the 17th century, they also laid claim to the beach, using the barrier islands primarily for grazing livestock. In the 1700s, records show there was whaling activity on the Currituck Banks. Some historians have noted there were more people living on this section of the barrier islands than on the mainland; others have reported that the area was largely uninhabited until well into the 1800s.

The communities of Wash Woods, Pennys Hill, and Currituck Beach were all established before the turn of the century but were renamed Deals, Seagull, and Corolla, respectively, by the federal government when post offices were opened in each village between 1895 and 1908. Some of the early residents worked at least part-time for the U.S. Life-Saving Service at Jones Hill or Caffey's (also called Caffrey's) Inlet.

Other jobs were found at the area's many hunt clubs, which were popular with wealthy Northern businessmen in the early 20th century. Outside the hunting and hurricane seasons, residents farmed and fished. The area had a year-round population of close to 200; Corolla was one of the larger villages on the entire Outer Banks.

Throughout most of the century, residents of the Currituck Banks had more connections to Virginia in their daily lives than to North Carolina. As the hunt clubs died out and changes in navigational technology eliminated the need for life-saving stations, many residents went to work in the Tidewater area. They shopped and went to the doctor and to church in Virginia. It was faster and easier to reach downtown Virginia Beach or Norfolk than Manteo or even Elizabeth City.

When the rest of the Outer Banks turned to tourism to sustain its economy, the Currituck Banks remained well off the beaten path. Hatteras Island got a modern highway in 1963, but the north beaches had no paved public thoroughfare until 1985. A private road closed to all but real estate agents and property owners was opened in 1975 from the Dare County line north to Ocean Sands, a real estate development south of Corolla. By the time the state road opened to Corolla, the village had dwindled to little more than a lighthouse surrounded by a derelict hunt club and a few dozen homes. The entire Currituck Banks had fewer than 500 houses, and most of them were second homes or vacation properties.

Very few postcards of Currituck Banks before 1985 exist.

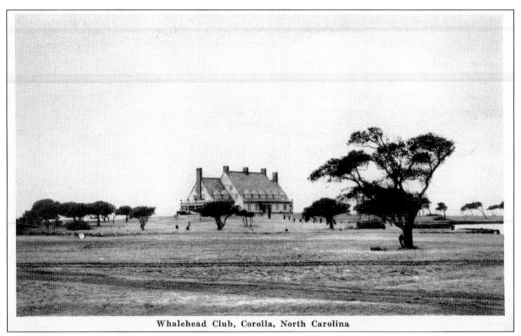

Whalehead Club, Corolla, North Carolina

THE WHALEHEAD CLUB. Edward Knight, a wealthy Philadelphian who made his fortune in railroads and sugar, had a French-Canadian wife who liked to hunt. To please her and indulge their love of entertaining, Knight built the extravagantly furnished Lighthouse Club on a picturesque spit of dredged land close to the Currituck Beach Lighthouse. The name was changed to Whalehead Club in 1940. (Courtesy of Michael G. Tames, date unknown.)

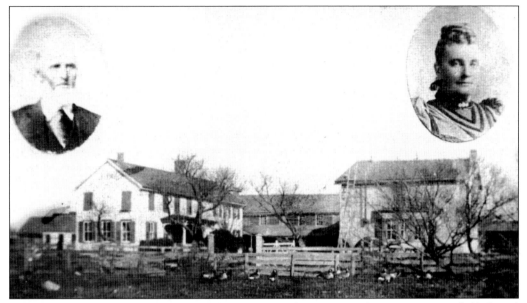

PALMER ISLAND CLUB. In the mid–1800s, Josephus Baum (shown at upper left) leased marshland and one of the buildings in this complex to a group of Boston sportsmen calling themselves the Palmer Island Club. Josephus and his wife, Caroline (shown at upper right), lived in the house on the left side of the photo. Their son, Julian, lived in the building on the right. (From the collections of the Outer Banks History Center, *c.* 1903.)

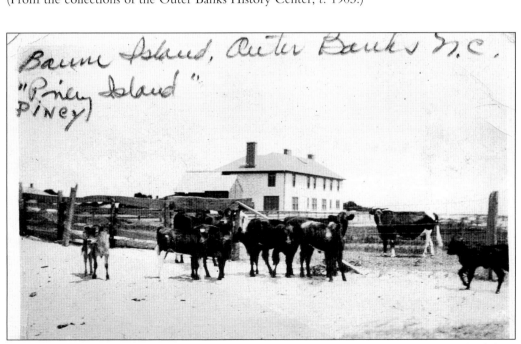

PINE ISLAND CLUB. The Baums sold their property to the newly formed Pine Island Club in 1910. The former Baum house and gun club was destroyed by fire in 1913. This was the new clubhouse built for the club that same year. It is still in use today as a private club. (From the collections of the Outer Banks History Center, 1916.)

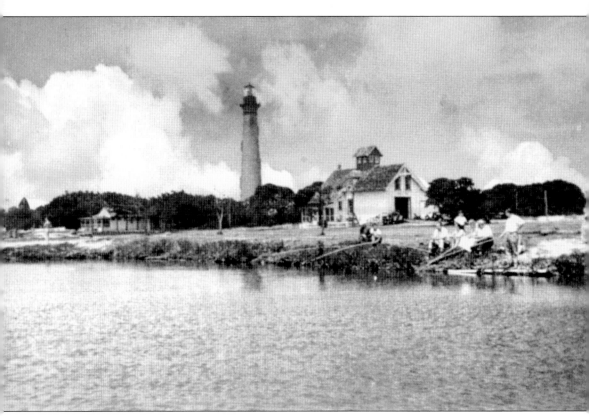

SOUNDSIDE AT COROLLA. Corolla was a village of fewer than 50 year-round residents when this photograph was taken near the Penny's Hill Life-Saving Station. The building was moved to Corolla in 1948 then moved again, twice, before it was destroyed by fire in the 1980s. The Currituck Beach Lighthouse is in the background. (From the collections of the Outer Banks History Center, *c.* 1955.)

Four
DUCK TO OREGON INLET

South of today's Currituck Banks, in an area that once was in Currituck County, lies the village of Duck. Until recent years, Duck had more in common with the communities to its north than with its neighbors to the south. Its men worked as fishermen and crabbers, as guides and keepers at Currituck's hunt clubs, or they entered federal service at one of the nearby life-saving stations.

Although the area was settled in the mid-1800s, the name "Duck" was established in 1909 along with its post office. The post office closed in the 1940s, but the name stuck. Most visitors to the Outer Banks had never heard of the place until the early 1980s, when Duck was featured in a national publication as the Outer Banks' "best kept secret." Once the secret was out, construction took off. In less than 20 years, almost every buildable piece of land within a two-mile radius of the village center was sold and developed. Those who loved Duck the way it was have fought to retain its narrow, tree-lined main street and the local character of its shops and galleries. The village incorporated as a town in 2002.

South of Duck is the planned community of Southern Shores. Started in 1947 as a real estate venture and incorporated in 1979, its low profile is a deliberate attempt to strike a balance between vacation destination and year-round town.

For most of the 20th century—from a vacationer's point-of-view—the 22 miles of beach that run from the Kitty Hawk Pier south to Coquina Beach was the best-known section of the Outer Banks. Kill Devil Hills, now the most populous municipality on the Outer Banks, may have been the first settled area along this stretch. Records show that people lived on the west side near Colington Island before the Revolutionary War. Ironically, this town is the least familiar. And while visitors know of Kitty Hawk and Nags Head, the boundaries have always been blurred by the uniformity of the landscape. Even today, for many visitors, it is all simply "The Beach."

The entire beach was once part of Currituck County, a political entity formed under the British Colonial government. Dare County was created in 1870, but the county's northern boundary ran through today's Kill Devil Hills, leaving Kitty Hawk and Duck in Currituck County. This was changed in 1920.

When the Wright brothers first flew in 1903, Kitty Hawk was the closest populated place. Kitty Hawk became the dateline, the place first flight happened. In fact, those first flights took place within what is now Kill Devil Hills, a town that did not exist on maps until its incorporation in 1953. Fogging the historical air even more, some claim the flights took place in Currituck County, whose southern boundary at the time is disputed and may have been very close to the Wrights' flight path. Most accepted histories put the flights in Dare County.

People had lived at Kitty Hawk Village, a sheltered and wooded west-side location on Kitty Hawk Bay, since the late 1700s. The first post office was opened there in 1878. When logging operations increased traffic on the Albemarle Sound at the southwest end of the village, a second post office, called Otila, was opened. It operated between 1905 and 1914. The Kitty Hawk Life-Saving Station was built on the oceanfront in 1874. It was not until the paved road opened in 1931 that development began at what was then called Kitty Hawk Beach. The two areas were united into one town with Kitty Hawk's incorporation in 1981.

About the same time that Kitty Hawk was settled, a less organized settlement began to take root in Nags Head Woods, about seven miles to the south, between Run Hill and Jockey's Ridge. Another settlement—primarily summer cottages—was established nearby, just south of Jockey's Ridge, in an area now commonly called Old Nags Head, although, until recent years, some also referred to the woods settlement as Old Nags Head. By the mid-1800s, residents of both places made part of their livings providing services to the resort that now included a hotel and steamship dock; the rest of the year, farming, fishing, and the Life-Saving Service were the mainstays. By the early 1900s, the woodland community had its own school, two churches, and a store. In 1923, Nags Head became Dare County's second incorporated town—the first was Manteo—but its incorporation was allowed to lapse.

Development along Nags Head Beach began in earnest after the Civil War. By the 1930s, the oceanfront replaced the soundside as the summer resort destination. Over the years, its name recognition as a resort was so strong that hotels and motels in Kill Devil Hills often advertised they were located at Nags Head Beach. Nags Head reincorporated in 1961, this time taking in land all the way to the Cape Hatteras National Seashore at Bodie Island.

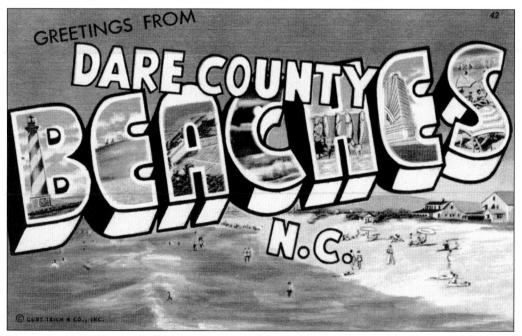

DARE COUNTY BEACHES. This card covers all the major attractions of the Outer Banks, from lighthouses to fishing. In 50 years, not much has changed; the beach is still number one. (From the collections of the Outer Banks History Center, *c.* 1955.)

KITTY HAWK VILLAGE. People were living at Kitty Hawk in the 1790s. By 1900, the soundside community had a population of over 250, split into "up the road" and "down the road" sections, each with its own church and school. The freight dock in this photograph ran to the E.W. Baum store and post office "down the road" on Kitty Hawk Bay. (Courtesy of Willard E. Jones, *c.* 1927.)

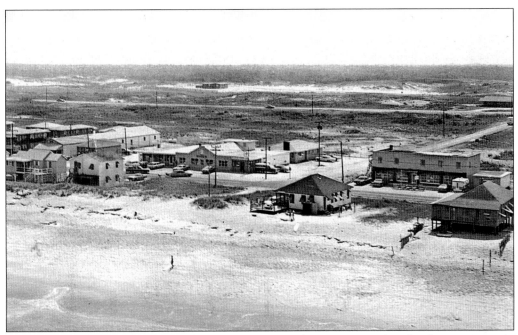

KITTY HAWK BEACH. With the U.S. Route 158 bypass just under development, nearly everything in Kitty Hawk outside the old village was on the beach road, including Winks (center), still open for business at milepost 2. The bypass was completed in 1959. The North Carolina Department of Transportation dropped "bypass" from the highway name in the 1980s. (Courtesy of Willard E. Jones, *c.* 1958.)

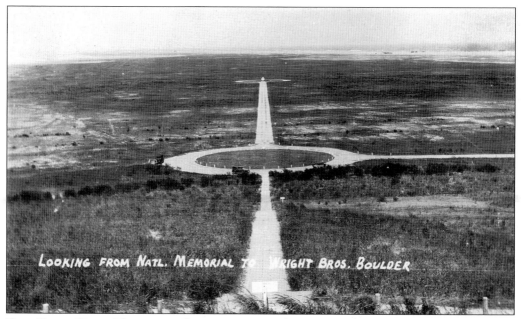

LOOKING FROM NATL. MEMORIAL TO WRIGHT BROS. BOULDER

KILL DEVIL HILLS. The name, of uncertain origin, first appeared on a map in 1808. It was then given to a life-saving station and a post office before the town was incorporated in 1953. The dunes were called the Kill Devil Hills; the tallest, Kill Devil Hill or the "Big Hill." This photo looks north, from the Wright Brothers monument on the Big Hill to the undeveloped oceanfront. (From the collections of the Outer Banks History Center, *c.* 1932.)

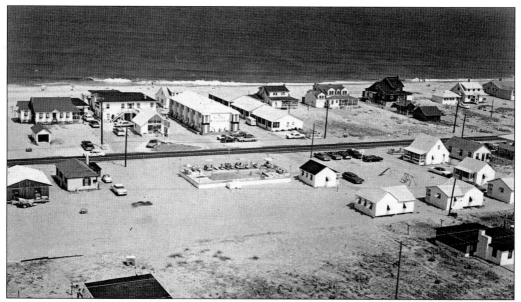

KILL DEVIL HILLS. In the late 1960s, this stretch of beach between mileposts 6 and 7 was lined with oceanfront motels, cottage courts, and private homes. Swimming pools—what few there were—were usually situated in view of the road, not the beach. By 2004, erosion had reduced the beach by more than half. Most of these buildings, including the Claydon Motor Lodge (upper center), are gone. (Courtesy of Willard E. Jones, *c.* 1972.)

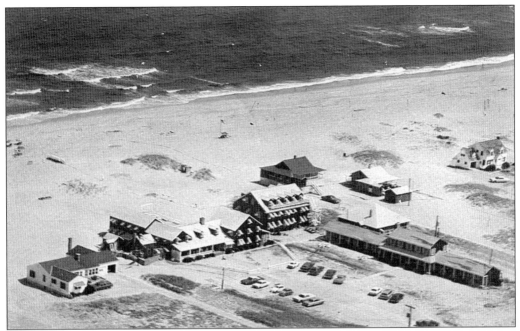

KILL DEVIL HILLS. The Croatan Inn at milepost 7.5, one of the oldest hotels on the beach, had expanded to several buildings when this photograph was taken. Today, only the original two-story building (left center) remains, reincarnated as Quagmires, a popular restaurant and bar. (Courtesy of Michael G. Tames, *c.* 1972.)

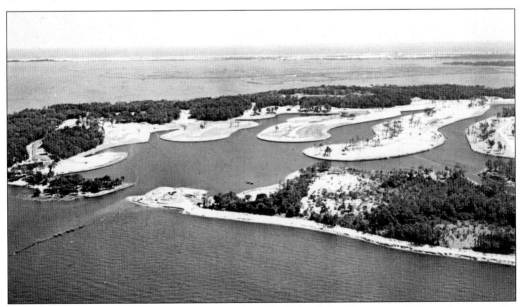

COLINGTON HARBOUR. Following national trends in land development, this gated community on Big Colington Island west of Kill Devil Hills featured deepwater canals, a yacht club, and a swimming pool. In 1968, out-of-town buyers were wooed with dinners and free trips to the Outer Banks. By the 1980s, Colington was a destination for locals wanting affordable year-round living away from summer crowds. (From the collections of the Outer Banks History Center, *c.* 1967.)

NAGS HEAD WOODS. Before paved roads, when a boat would not do locals often used horse- or ox-drawn carts. The carts were also popular with visitors, who hired them to visit the sights in Nags Head Woods. This road leads to the fresh ponds and is probably the present-day Old Nags Head Woods Road. (Courtesy of Willard E. Jones, *c.* 1920.)

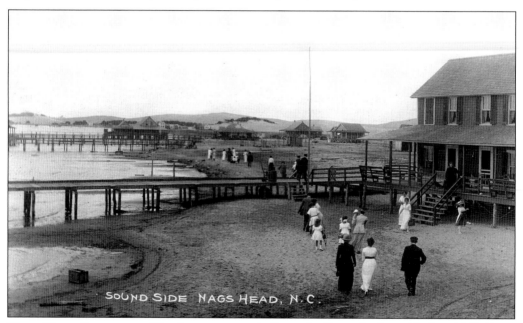

NAGS HEAD SOUNDSIDE. The first resort was built on the Roanoke Sound before 1860. Boats brought visitors to the soundside docks. The resorts provided cart rides to the ocean. The owner of the Nags Head Hotel built a rail line to the beach in 1886. Both the hotel and railway were gone when this photo was taken around 1900. (Courtesy of Willard E. Jones, *c.* 1917.)

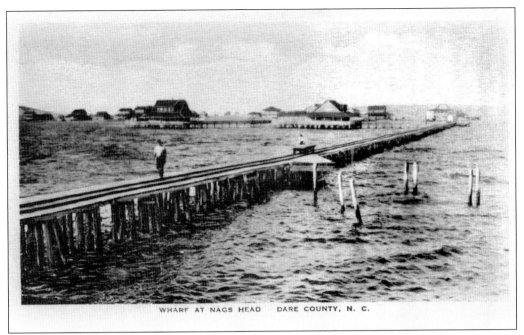

WHARF AT NAGS HEAD DARE COUNTY, N. C.

NAGS HEAD DOCKS. Until the opening of the Wright Memorial Bridge at Kitty Hawk and the paved road to Nags Head in 1931, almost all building supplies, groceries, household goods, fuel oil, and everything else visitors and property owners needed were brought to the beach by boat. The commercial soundside dock at Nags Head was equipped with rails to ease freight movement. (Courtesy of Willard E. Jones, 1931.)

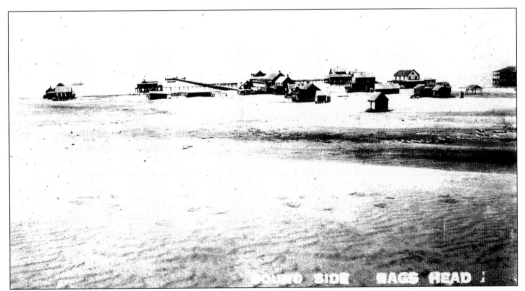

OLD NAGS HEAD. When this postcard of Old Nags Head was made, summer residents were beginning to build homes on the oceanfront. A few of these original soundside buildings, located south of Jockey's Ridge, were later moved to the oceanfront; some were covered by sand from the large migrating dune field that included Engagement Hill, where this picture was taken; most are gone. (Courtesy of Willard E. Jones, c. 1924.)

39

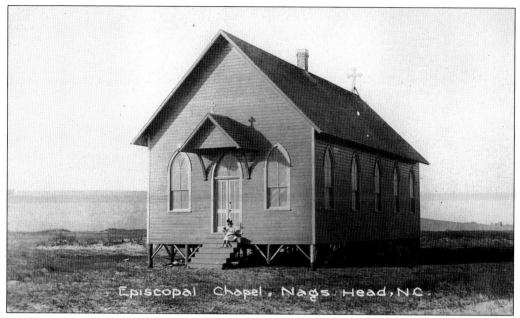

ST. ANDREWS-BY-THE-SEA. Stephen Twine, an Elizabeth City carpenter, built this Anglican chapel near the sound in 1915. It replaced Nags Head's first church, built for summer use in 1849, which was torn down during the Civil War by Union troops needing lumber. Twine's chapel was moved to the west side of the beach road at milepost 13 in 1937. (Courtesy of Michael G. Tames, *c.* 1917.)

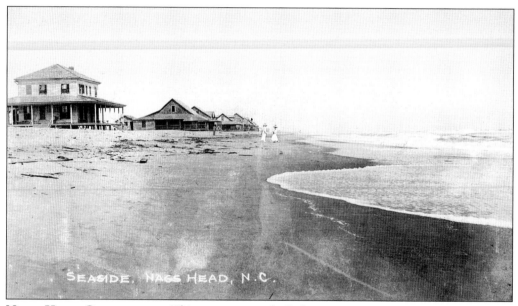

NAGS HEAD OCEANFRONT. Thirteen cottages built between 1855 and 1889 made up the original "Unpainted Aristocracy" on Nags Head's oceanfront. Nearly two dozen cottages between mileposts 12.5 and 14 were recognized when Cottage Row was put on the National Register of Historic Places in 1977, including the Pruden-Battle-Clark Cottage, built before 1900, shown at far left. This photograph was taken around 1900. (Courtesy of Michael G. Tames, 1926.)

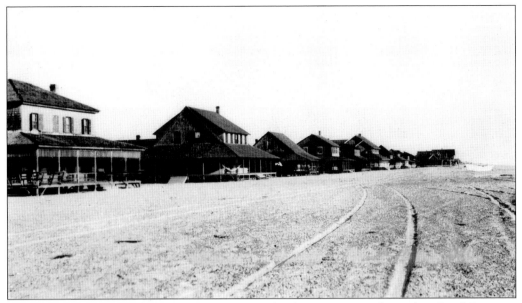

NAGS HEAD OCEANFRONT. This later photograph of Cottage Row shows the Wood–Foreman Cottage, built next to the Pruden–Battle–Clark Cottage in 1916 by Stephen Twine, creator of the classic Nags Header cottage. To the right of Wood–Foreman are the MacMullan and Nixon Cottages, both built in 1866 and part of the original 13. (From the collections of the Outer Banks History Center, *c.* 1925.)

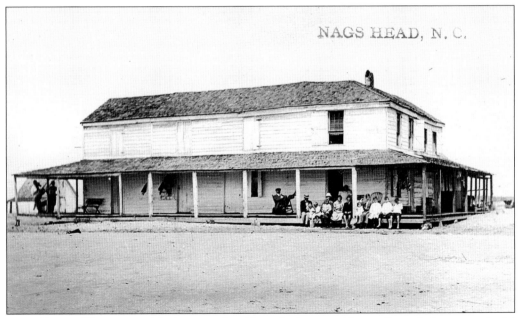

NAGS HEAD. The name origin is uncertain, although pirates and horses figure in its most colorful legends. Most likely, the name came from England, where Nags Head was a place name for various land formations and a seaside village. This large farmhouse-style building was built before Twine introduced his shingle-style cottages to the beach. It may have been a store. (Courtesy of Willard E. Jones, 1909.)

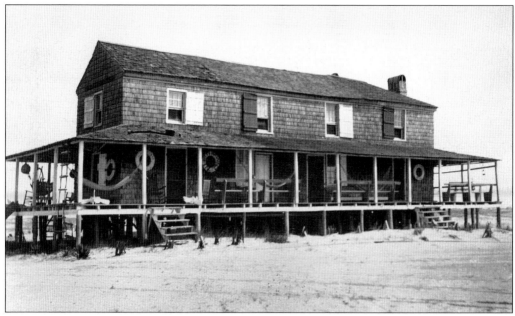

NAGS HEAD. Although this unidentified cottage with its hammocks and life preservers lacks the signature "Nags Header" details credited to Twine—sweeping, gabled roofs that formed wide, covered porches, full dormers, awning-style shutters, and lean-out benches integrated into porch railings—it would still fit in Cottage Row today. (Courtesy of Willard E. Jones, 1937.)

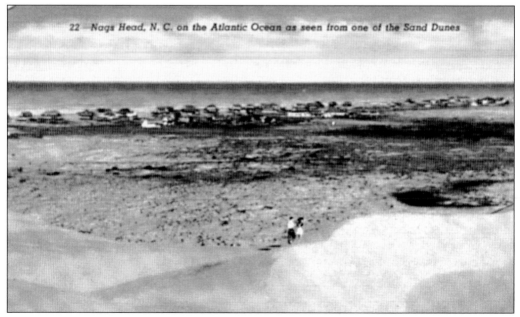

NAGS HEAD. When houses were built on the oceanfront, seen here from Jockey's Ridge, locals called the old Nags Head community Sound Side. The first post office opened in 1884 as Nags Head, but nine years later, the name was changed to Nagshead. A second post office designated Griffin opened in 1909. After the Nagshead office closed in 1915, the Griffin Post Office was renamed Nags Head. (From the collections of the Outer Banks History Center, *c.* 1955.)

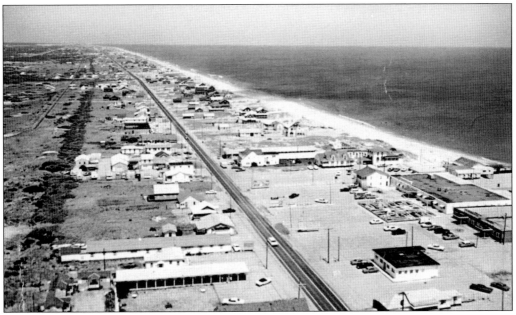

Nags Head. From the 1950s through the 1970s, the town's entertainment hub began around milepost 12 with the Nags Head Fishing Pier (center right) and the adjacent Manns Recreation Center, later called Foosball Palace. Although the pier and its pier house are still there, most of the other commercial buildings are gone, replaced by oceanfront vacation homes. (From the collections of the Outer Banks History Center, *c.* 1967.)

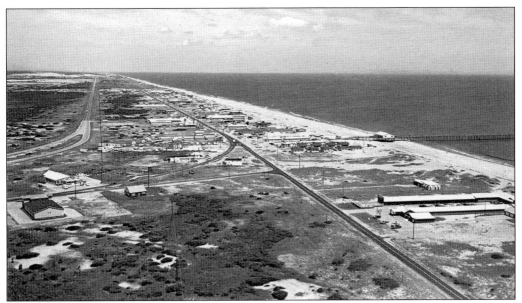

Whalebone Junction. Taken shortly after the bypass was completed, this view of Nags Head shows Jennette's Pier at right center; the Dolphin Motel at lower right is still in business. The old Shrine club (at left with the dark roof) is now Holy Trinity Catholic Church. The large expanse of empty land in the upper left is now the Village at Nags Head. (Courtesy of Michael G. Tames, *c.* 1960.)

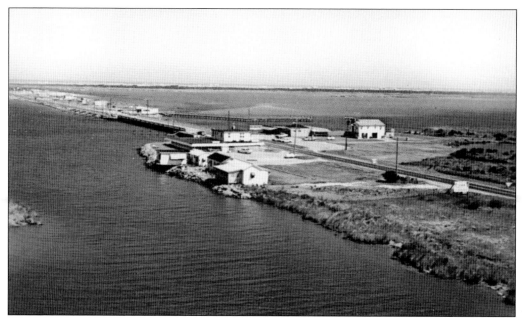

NAGS HEAD–MANTEO CAUSEWAY. Thirty years after it opened, the causeway was a popular spot for restaurants and bait shops—businesses that still find the "in between" location a good one. The Oasis (left) and Reef restaurants sat across the road from each other in the center of this picture. Both, now gone, provided summer housing for employees in the surrounding cottages. (From the collections of the Outer Banks History Center, *c.* 1960.)

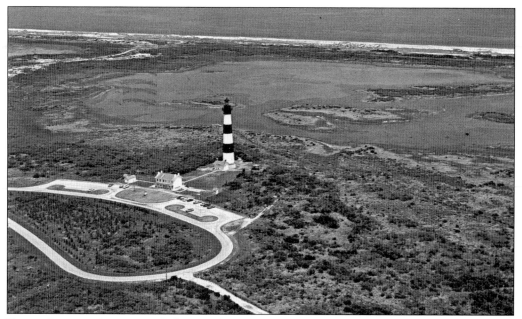

BODIE ISLAND. Opening and closing inlets have left Bodie Island attached to Nags Head in its present configuration since 1846. The land shown in this aerial, from State Route 12 west to the Roanoke Sound, is the north end of the Cape Hatteras National Seashore. (Courtesy of Michael G. Tames, 1966.)

Five

ROANOKE ISLAND

In geological terms, Roanoke Island is a barrier island on its way to becoming mainland real estate. Thousands of years ago, before the sea reached its present level, Roanoke Island's east coast was ocean beach and the Outer Banks ridge we know today was still submerged. As the Atlantic coast's barrier islands migrate to the southwest as they are meant to do, they eventually meet up with terra firma, explains geologist Orrin Pilkey in How to Read a North Carolina Beach: *"Many coastal communities such as Harkers Island, Beaufort, and Morehead City occupy these onetime islands."*

In many ways, it is a fitting description of the island in human terms. It's not quite beach resort, not quite mainland. Its solid, year-round population base, a core business community not dependent on seasonal visitors, and seat-of-government infrastructure makes its economy less tourist-oriented than its barrier island neighbors.

But Roanoke Island is still surrounded by water. Though now protected from the ocean by newer islands, it is still at risk in severe weather. Access to the island is dependent upon manmade means that can be cut off in the five minutes it takes a barge to break its anchor and crash into a bridge piling. There is something about this exposure to chance that attracts people who like to live on the edge, people who seem to crave both community and isolation. The line between island life and mainland life cannot be quantified or even explained—it just is. And Roanoke Island is all island in that respect.

Its sheltered location behind the barrier strand made Roanoke Island the site of considerable English attention in the mid-1580s. Three separate expeditions financed by Sir Walter Raleigh attempted to establish a colony here. The last colony of more than 100 men, women, and children was intended to be permanent. It failed for reasons not completely understood. The colonists were gone three years later when the colony's governor, John White, who had gone back to England for supplies, was able to return. No survivors or written records were ever found.

The mystery of this first attempt to establish an English colony in the New World—years before Jamestown, Virginia, or Plymouth, Massachusetts—is the basis for The Lost Colony, *America's longest-running outdoor drama, first performed on Roanoke Island in 1937.*

After Raleigh's colonists quit the island, settlers did not return until more than 70 years later. According to David Stick's The Outer Banks of North Carolina, *an agreement was made in 1654 with the Roanoke Indians who occupied the island "for the Indians to move inland and turn the coastal area over to the Virginians." By the early 1700s, several families were farming the island. Their names, including Baum, Daniels, Mann, and Meekins, figure prominently in island history through the present day.*

45

The Revolutionary War brought little change to the isolated island. One distant government was exchanged for another; national politics were not important in its daily life.

The Civil War was more keenly felt by the island's permanent residents, who then numbered about 500. Residents generally sided with the Union in spite of their location well below the Mason-Dixon line. Union general Ambrose Burnside's troops occupied the island, winning a small but strategically significant battle here in 1862.

After Burnside's victory, a Freedmen's Colony of more than 3,000 freed or runaway slaves and their families was established on seized property at the north end of the island. The colony was forced to disband in 1866 when former property owners claimed reparations. Some of the families stayed on the island; several men went to work at Pea Island Life-Saving Station, where, as the only all-black life-saving crew in the nation's history, they also became one of the most successful.

In the later years of the 1800s and into the 1900s, many of the island's men worked for the U.S. Life-Saving Service and its successor, the Coast Guard. Their families lived on Roanoke Island to be close to schools, church, and other community facilities not available on the outer islands.

In those same years, a small community settled at Skyco, also spelled Skiko but known as Ashby's Harbor until the U.S. Post Office changed the name in 1892. Its harbor became a port-of-call for the Old Dominion Steamship Company. After steamship business declined, the post office closed in 1913.

Wanchese, at the lower end of Roanoke Island, had more staying power as the commercial fishing center of the Outer Banks. Although many of its major operations have moved out of Wanchese Harbor because of shoaling at Oregon Inlet, the companies started here still retain their ties to the old village.

The post office was also responsible for changing the name of Roanoke Island's upper end village, Shallowbag Bay, to Manteo when it opened an office there in 1873, three years after the community was designated the seat of government for the new county of Dare. The town of Manteo was not incorporated until 1899. It remains the island's only municipality.

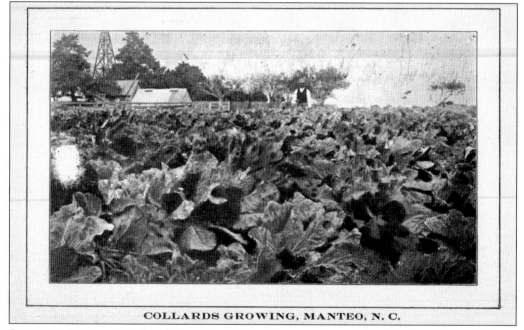

COLLARDS GROWING, MANTEO, N. C.

ROANOKE ISLAND. Until well into the 1950s, a large portion of the island was farmed. There were peach orchards and vineyards, a dairy farm, hogs, sheep, and chickens. Even those living in town had large gardens. Collards were one of several crops grown for cash and for the family dinner table. (Courtesy of Willard E. Jones, early 1900s.)

General Burnside's Headquarters 1863, Roanoke Island, N. C.

UNION ARMY HEADQUARTERS. Union general Ambrose Burnside landed at Ashby's Harbor (present day Skyco) in February 1862. As his troops routed the Confederates, Burnside commandeered this house for his headquarters. Though it no longer exists, it was located on the shore of the Croatan Sound, near today's Burnside Road. Burnside's victory took less than two days, and he left the island a month later. (Courtesy of Michael G. Tames, *c.* 1930.)

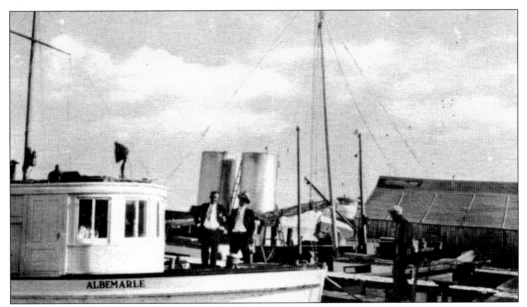

MANTEO DOCKS. Manteo's access to the water was one reason behind its choice as county seat in 1870. Until highways and bridges connected the island to the mainland in 1930, boats were the primary means of transportation. The docks were the town's center of commerce. (From the collections of the Outer Banks History Center, *c.* 1930s.)

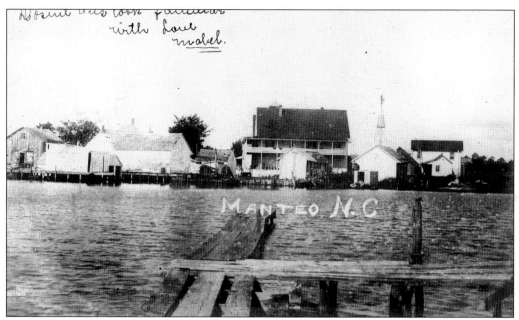

MANTEO WATERFRONT. The Roanoke Inn apartments faced Dough's Creek on the north side of downtown. The first floor was used for business, while the upper floors were rented out. Today, the inn is gone. The land where it sat serves the town as a boat ramp and parking lot. (From the collections of the Outer Banks History Center, *c.* 1930.)

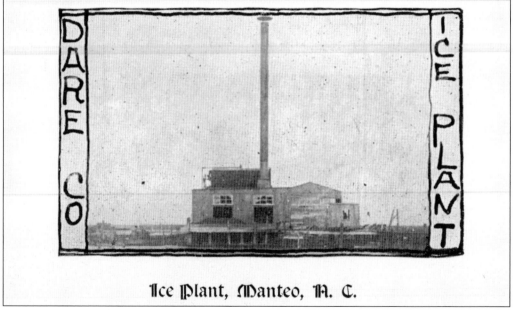

ICE PLANT, MANTEO. In the days of sailboats and steamers, Manteo's fishermen needed ice to get their oysters, shad, and other fish to Northern markets. When this privately owned ice plant on Dough's Creek, where Festival Park and the Outer Banks History Center are today, burned down in the early 1900s, a fishing cooperative built a new plant across the creek on the Manteo waterfront. (Courtesy of Willard Jones, date unknown.)

48

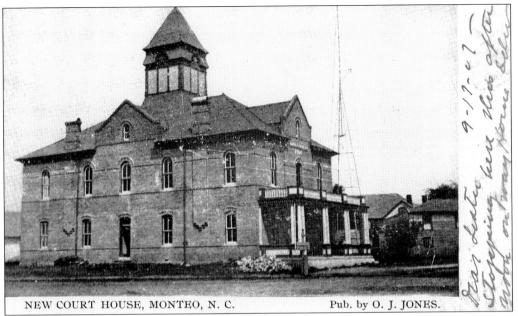

NEW COURT HOUSE, MONTEO, N. C. Pub. by O. J. JONES.

DARE COUNTY COURTHOUSE. By 1900, Manteo needed a new courthouse. Four years later, a red brick courthouse modeled after one in Tyrrell County replaced the two-story, wood-frame building, which was moved around the corner and eventually sold. After serving as classrooms for the overcrowded consolidated school, apartments, the original Bank of Manteo, and other stores, the old courthouse was destroyed in a 1932 fire. (Courtesy of Michael G. Tames, 1907.)

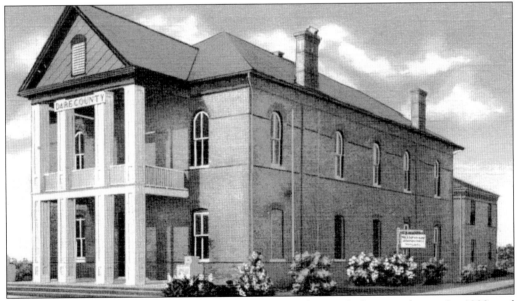

DARE COUNTY COURTHOUSE. When a hurricane damaged the courthouse in 1933 and destroyed its bell tower, the county took the opportunity to update its Italianate façade with a modified Federal-period look. During renovations in the 1970s, the architectural vernacular shifted again with the addition of Greek Revival–style columns. (From the collections of the Outer Banks History Center, 1937.)

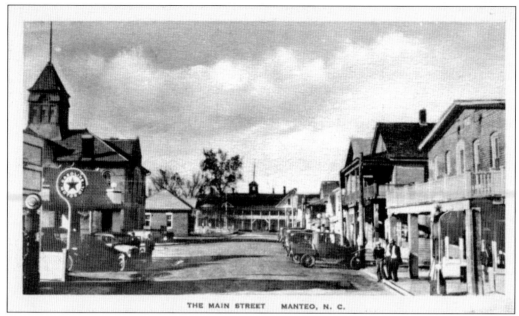

THE MAIN STREET MANTEO, N. C.

WATER STREET, MANTEO. Renamed Queen Elizabeth Avenue in 1976, the street closest to the Manteo docks was the town's main street for more than 50 years. Shops lined the waterfront with rooms for rent upstairs. The Roanoke Inn sat at the end of the street. At left, the courthouse bell tower is visible behind the Texaco station (now the Full Moon Café). (Courtesy of Michael G. Tames, *c.* 1931.)

VILLAGE OF MANTEO, N.C.
NAMED FOR INDIAN FRIEND OF THE
COLONISTS

HIGHWAY STREET, MANTEO. By 2004, Hotel Fort Raleigh had found new life as an office building, and the Esso gas station was long gone, but the Pioneer Theatre (left center) was still showing family movies every night of the week. Originally opened a block away in 1918, the theater was moved to this location in 1934 by its owners, the Creefs. (Courtesy of Michael G. Tames, *c.* 1937.)

GRADE SCHOOL MANTEO, N. C.

MANTEO CONSOLIDATED SCHOOL. The town's first public or "free" school began around 1912. This schoolhouse was built three years later at what is now the corner of Budleigh Street and U.S. Highway 64. Before the public school opened, many island children, black and white, attended the nearby Roanoke Academy, a school with roots in the Freedmen's Colony of the 1860s. (Courtesy of Michael G. Tames, 1930s.)

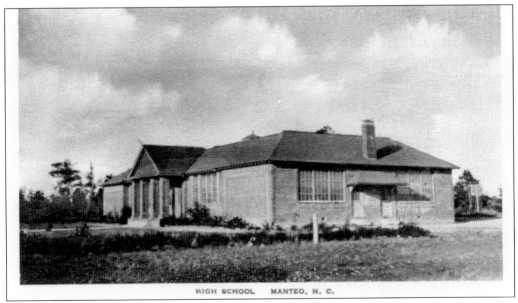

HIGH SCHOOL MANTEO, N. C.

MANTEO HIGH SCHOOL. The consolidated school had seven elementary and four secondary grades under the same roof. Although many older students left to attend boarding schools or work, the first high school class graduated in 1916. A new high school, shown here, opened in 1925. It was torn down in the 1970s to make way for the current Manteo Elementary School. (From the collections of the Outer Banks History Center, 1930s.)

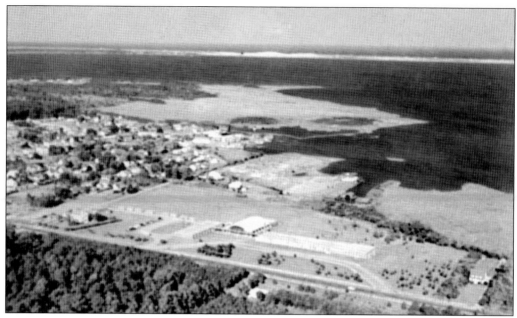

MANTEO. A new high school was needed in the 1950s, when students from the beach began attending Manteo schools. The modern campus, built in 1958 on the south edge of town, shown in this aerial looking northeast, is currently Manteo Middle School. (From the collections of the Outer Banks History Center, 1973.)

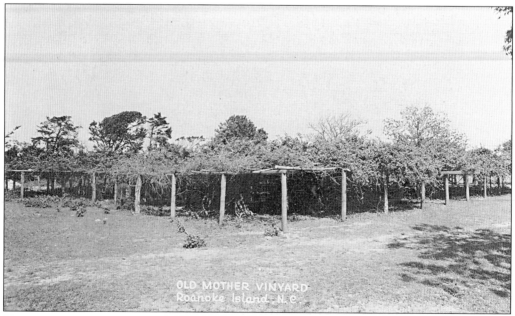

OLD MOTHER VINYARD
Roanoke Island - N. C.

MOTHER VINEYARD. The name refers to both this Scuppernong grapevine and the surrounding neighborhood, once a large farm that bottled its own "Mother Vineyard" wine. At that time, the vine, possibly the oldest existing Scuppernong vine, covered nearly two acres. Legend claims the vine predates Raleigh's attempted colonies on the island. Pruned to a more manageable size, it grows today on private property. (Courtesy of Michael G. Tames, 1938.)

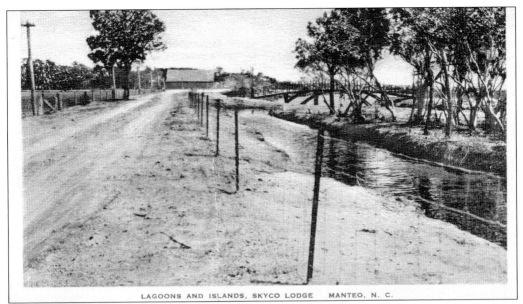

LAGOONS AND ISLANDS, SKYCO LODGE MANTEO, N. C.

SKYCO. The area was known as Ashby's Harbor when Burnside's naval commander used the deepwater port for landing troops in 1862. After the war, Old Dominion Steamship Company established its Roanoke Island freight and passenger terminal here. Passengers bound for Nags Head were taken to the Manteo docks to catch other boats to the beach. (Courtesy of Michael G. Tames, 1930s.)

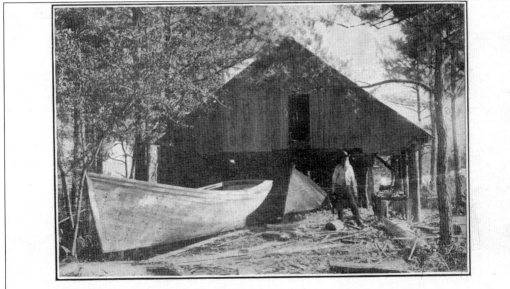

WHERE THE TYPICAL N. C. "SHAD BOATS" ARE BUILT.

SHAD BOAT. George Washington Creef Sr., shown here at his Wanchese boathouse around 1890, designed and built his first shad boat in the 1870s. The small working craft had a tapered bow and stern with a round bottom for easier handling in the rough, shallow waters of northeastern North Carolina's sounds. Its wide beam carried more fish than other workboats of the day. (Courtesy of Willard E. Jones, c. 1910.)

53

This windmill, still standing, was erected some time after SIR WALTER RALEIGH'S COLONISTS landed on Roanoke Island.

At one time it ground all the grain used in this section. It is located just outside the town of MANTEO, N. C.

ROANOKE ISLAND WINDMILL. In the 1800s, many windmills were built on the Outer Banks to harness wind power for grinding grain. By the early 1900s, there were at least two still standing: one at Mill Landing on the southeast shore of the island and this one, built after the Civil War, just south of town on the road to Wanchese. (From the collections of the Outer Banks History Center, *c.* 1908.)

Six

HATTERAS AND OCRACOKE ISLANDS

Until humans intervened, the configuration of the southern beaches of the Outer Banks was always changing. Several inlets, opened and re-opened by storms along this stretch of coastline, made new islands out of old in the blink of a hurricane's eye.

More than once, Pea Island has been a true island, separated most recently from Hatteras in 1933 when an old inlet—sometimes called New Inlet—reopened. The inlet closed again in 1945. Before Oregon Inlet cut them apart in 1846, Pea Island was part of Bodie Island. Hatteras Inlet opened during the same 1846 hurricane, ending the island's 100-year attachment to Ocracoke and providing Confederates with a geographical advantage in controlling the state's inland waterways during the Civil War. For at least 100 years before that, Hatteras Island real estate included the eastern part of Ocracoke Island, thanks to an old Hatteras Inlet nearly eight miles to the west.

Place names of these islands are just as confusing as the geography. Although all historians are not in agreement, it is generally believed that before the English came to the Outer Banks, a tribe of Algonquin Indians had settled in the high woods near Cape Hatteras (present-day Buxton), referred to in histories of Raleigh's colonies as Croatoan. If this is so, it was the only permanent Indian settlement on the Outer Banks. This same area is sometimes called Hatorask.

This confusion of places goes back to Raleigh's expeditions. It is fairly certain that ships on at least one of the voyages stopped at either Ocracoke or Hatorask, depending on which inlet was opened or closed, before sailing on to Roanoke Island.

Little is known about the early settlers of Hatteras Island except that they must have been self-reliant and hardy, able to survive isolation and the assault of the area's volatile weather. Throughout most of the 1700s and 1800s, there was more action offshore than on, as ships supplying the American colonies followed the westerlies across the Atlantic and then caught the Gulf Stream up the East Coast. It was a difficult coast to sail; shipwrecks and groundings were frequent.

The federal government struggled to make navigation along the coast safer. Construction of lighthouses and, eventually, several life-saving stations aided navigation and also created jobs. Lightkeeping and life-saving service became family traditions.

Hatteras Island had little involvement in the Revolutionary War. During the Civil War, after months of Confederate privateering and naval assaults on shipping lanes crucial to the North, Union troops attacked the

two forts flanking Hatteras Inlet and quickly gained control. This amphibious assault, launched by joint land and navy forces, was the first of the war and gave the Federal troops their first victory in the South.

In Colonial days, Ocracoke Inlet had been the key, but difficult, passage to inland waterways. The North Carolina Assembly voted to establish pilots at the inlet in 1715. Although a few pilots moved to the island, the village was not permanently settled until somewhat later. By the time shoaling closed the inlet to shipping in the late 1800s, commercial fishing and government service had replaced piloting as the island's primary livelihood.

In 1718, commerce at the inlet had a new threat—pirates. For several months that year, Edward "Blackbeard" Teach used an anchorage at the southern end of Ocracoke Island on the Pamlico Sound. He was blamed for numerous hijackings and robberies of ships passing through the inlet. By the end of November, he was dead, killed near the anchorage by Lt. Robert Maynard of England's Royal Navy.

The establishment of the national seashore in 1953—the country's first—was pivotal in the development of both Hatteras and Ocracoke Islands. With the exception of their established villages—Rodanthe, Waves, Salvo, Avon, Buxton, Frisco, Hatteras, and Ocracoke—almost all the land from Oregon Inlet to Ocracoke Inlet was acquired by the federal government. Creation of the park was an economic boon, increasing tourism and, in turn, creating more jobs.

Development confined by park boundaries has left hundreds of acres of nearly pristine landscape. As along all Outer Banks beaches, most of the beach dunes are man-made. The opportunity to drive through miles of this unique barrier island habitat is a great gift for anyone whose vistas are usually filled with urban clutter and suburban sprawl.

By 1963, paved roads, bridges, and state-operated ferry service connected both islands to the rest of the world, but neither island rushed to change. Consequently, they remain the most low-key and laid-back destinations on the Outer Banks. Visitors who truly want to get away can still find clean, comfortable rooms with no telephone or television. Both islands still cater to the vacationer of modest means or the sportsman who wants only a soft bed, a good supply of ice, and a handy place to clean his fish.

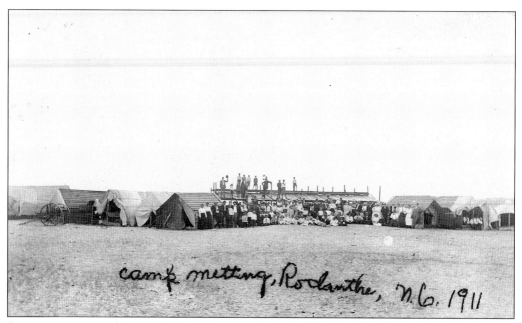

RODANTHE. One of three villages near the north end of Hatteras Island, Rodanthe was known as Chicamicomico—a name that actually referred to the entire north end—before the name was changed when the post office opened in 1874. The area was settled as early as 1744. This postcard is believed to be one of the oldest in existence depicting a Hatteras Island scene. (Courtesy of Michael G. Tames, 1911.)

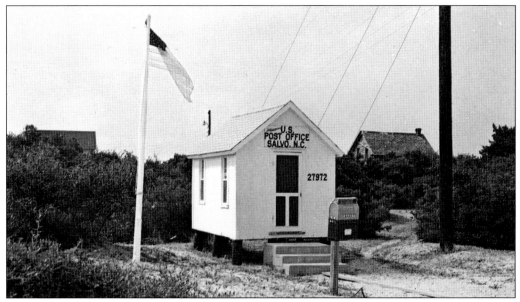

SALVO. When first settled, Salvo was considered part of Chicamicomico. Later, it was called Clarks. Salvo came into use after the Civil War and became its official name when the post office was established in 1901. This 8-by-12–foot post office, built around 1908, was the second smallest in the nation. It remained in service until damaged in a fire in 1992. (From the collections of the Outer Banks History Center, 1970s.)

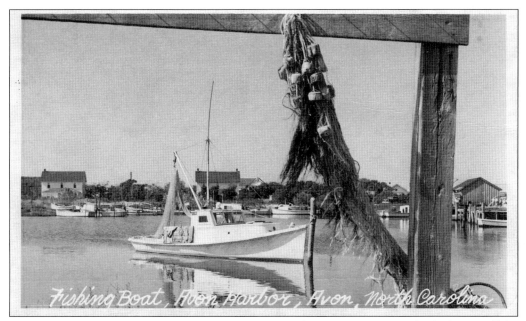

AVON HARBOR. Dredged by the U.S. Army Corps of Engineers in 1946, the harbor is off the highway, unseen by most visitors to Hatteras Island. In the late 1800s, steamers docked at freight houses built in the sound here, and boats were built along the shore. Today, it is a working fishing center. Until the post office opened in 1873, the village was called Kinnakeet. (Courtesy of Willard E. Jones, 1950s.)

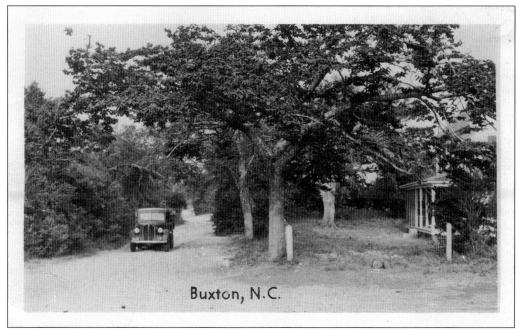

Buxton, N.C.

BUXTON. Called "The Cape" until 1882, nine years after the post office was established, this was one of the first populated places on Hatteras Island because of the thick cover of its maritime forest west of the cape. The most probable location of this photograph is in front of the present-day Buxton Village Books, looking west toward Trent (now called Frisco) and Hatteras Village. (Courtesy of Michael G. Tames, 1940s.)

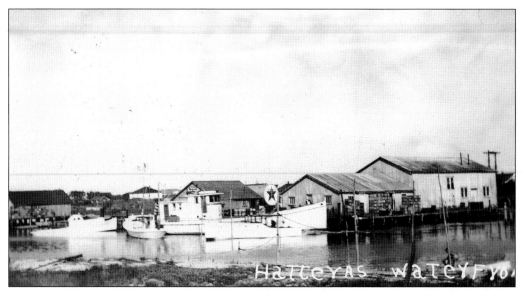

HATTERAS VILLAGE WATERFRONT. Now Oden's Dock, this marina—once owned by Maurice "Dick" Burrus, an Outer Banks native who played Major League baseball—was the site of the island's first electric generator and ice plant in 1935. The village was the first on the island to get a post office, too, established in 1858, although it closed periodically over the next 20 years. (From the collections of the Outer Banks History Center, *c.* 1947.)

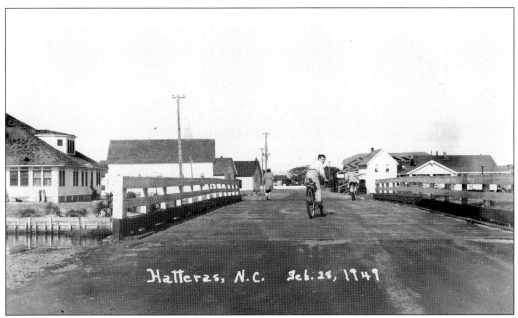

THE SLASH, HATTERAS VILLAGE. The highway bridge shown here crosses the Slash, a creek running through the village from Pamlico Sound. The Girls' Club (first building on left) was built by George Lyons in the 1930s. The Hatteras Medical Center sits where the club once stood. (From the collections of the Outer Banks History Center, 1949.)

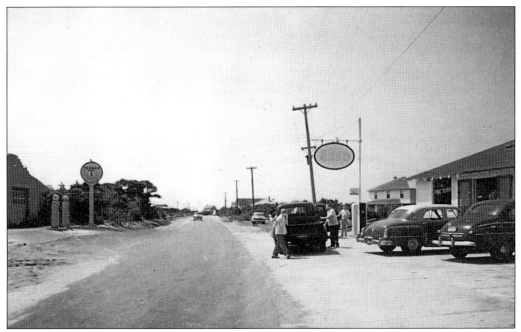

HATTERAS VILLAGE. West of the Slash bridge, the highway turns toward the new ferry docks, which were moved from the village further west about the time this photograph was taken. The Texaco station on the left is still a gas station, located next door to Midgett Realty on Highway 12. (From the collections of the Outer Banks History Center, c. 1955.)

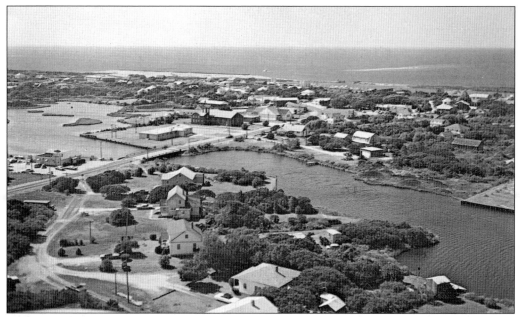

HATTERAS VILLAGE. The Slash is clearly visible in this view looking west toward the Pamlico Sound. The Channel Bass restaurant on the east side of the bridge is still there. On the west side, the Girls' Club building has already been replaced. (Courtesy of Michael G. Tames, 1972.)

HOWARD STREET, OCRACOKE VILLAGE. Named for one of the island's first families and laid out in the mid–1800s as the main road, it was once nearly twice as wide. It was also longer, but it was shortened when the highway was built in 1950s. The remaining street looks much as it did 75 years ago. (From the collections of the Outer Banks History Center, date unknown.)

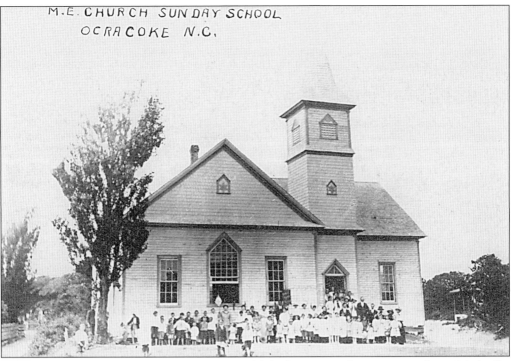

M.E. CHURCH SUNDAY SCHOOL OCRACOKE N.C.

WESLEY CHAPEL, OCRACOKE VILLAGE. Established in 1908, this was one of two Methodist churches on the island. The other, affiliated with the Methodist Episcopal Church, South, started in 1869. The two branches of Methodism reunited in 1937. A new church for the combined congregations was built in 1943. Wesley Chapel, located off Back Road, was torn down. (Courtesy of Willard E. Jones, *c.* 1920.)

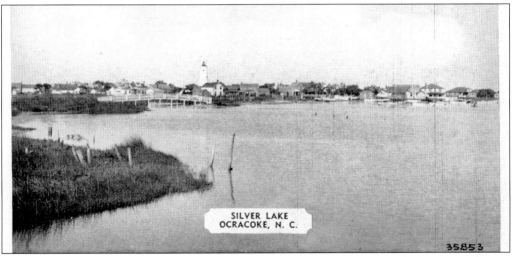

SILVER LAKE
OCRACOKE, N. C.

35853

COCKLE CREEK, OCRACOKE VILLAGE. The Army Corps of Engineers first dredged Cockle Creek in 1931, making it more suitable for large-scale fishing operations and military use. The new harbor was named Silver Lake. Two wooden footbridges crossed sections of the old creek before the harbor was dredged again in the 1940s, leaving the shoreline much as it looks today. (Courtesy of Michael G. Tames, 1939.)

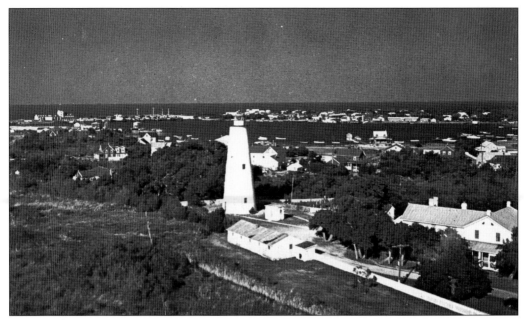

OCRACOKE VILLAGE. In Colonial times, nearly all shipping for North Carolina's northern regions and her Colonial cities passed through Ocracoke Inlet, one of North Carolina's oldest and most stable passages to her inland waterways. The island has seen naval action during every war fought along the Atlantic Coast. Today, the harbor draws recreational sailors who enjoy the quaint, pedestrian-friendly village. (From the collections of the Outer Banks History Center, date unknown.)

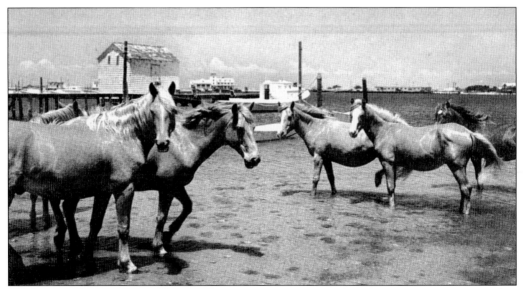

OCRACOKE PONIES. For years, islanders used the horses for work and recreation but—other than periodically thinning the herd—let them run free. The highway and establishment of the national seashore made it necessary in the early 1960s to reduce the herd to about 30 horses and confine it to soundside pastures. (Courtesy of Hugh Morton, from the collections of the Outer Banks History Center, *c.* 1955.)

Seven

LIFE-SAVING LEGACY

By the early 1800s, cargo ships and, to a lesser extent, passenger ships plying the waters of the Atlantic Coast were an important part of the American economy. Shipwrecks were frequent and costly. There were few places on earth more inhospitable to ships than the shoals along the isolated North Carolina coast. News reports referred to this treacherous section of coast as the "Graveyard of the Atlantic," and the well-deserved name stuck.

The federal government had assumed responsibility for all navigational lighthouses, beacons, and buoys in 1789. On the Outer Banks, efforts to avert more tragedy began by marking Royal Shoal off Ocracoke and building a small lighthouse at Shell Castle Island. Next, in 1802, came a lighthouse at Cape Hatteras, the predecessor to the familiar spiral-striped tower of today. When the Shell Castle tower was destroyed in a lightning strike in 1818, plans for the Ocracoke Lighthouse got underway. The first of three towers at Bodie Island was finished in 1848. The lighthouse at Currituck Beach was not put into service until 1875.

There were numerous lightships and other beacons placed to mark dangerous shoals, rivers, and narrow channels through the sounds.

But along the dangerous Atlantic coast, lighthouses alone were not enough. Congress officially established the U.S. Life-Saving Service in the 1870s as the first federal program mandated to aid imperiled ships and save the lives of shipwreck victims.

The first seven Life-Saving Service stations on the Outer Banks were built in 1874. By 1888, there were 21 stations located approximately six miles apart between the Virginia border and Ocracoke.

Lighthouses and life-saving stations brought government work to a place where fishing and subsistence farming had sustained a meager economy. Although the Life-Saving Service employed most of its crews—called surfmen—on a part-time basis, regular paychecks for part of the year made a substantial difference. The keeper at each station was employed year-round. Any job with the Life-Saving Service was sought after, and men who held them were respected within their communities. The tradition of men following their fathers, brothers, and uncles into the service lasted through several generations, continuing after the Life-Saving Service became part of the Coast Guard in 1915.

Prior to establishment of the Life-Saving Service, locals were known to help shipwreck victims who made their way to shore. The ships, however, were always fair game—and, for the Outer Bankers, they were an important source of building materials and other goods in short supply on an isolated barrier island. In theory, the Life-Saving Service inhibited the looting of ships, although history suggests that old habits died hard.

History is clear about the dozens of rescues carried out by the life-saving crews and the hundreds of lives they saved. They left a legacy of daring and dedication that, even today, seems impossibly heroic.

In between shipwrecks, the crews farmed, fished, and found other ways to make themselves useful. The crews of the Kitty Hawk and Kill Devil Hills Life-Saving Stations played a role in the development of the airplane. If not for the stations along the coast, there would have been no weather bureau office at Kitty Hawk for Wilbur Wright to contact. Without the weather bureau, he would have never come to the Outer Banks.

Once here, Wilbur and his brother, Orville, relied on telegraph services at the Kitty Hawk station to keep in touch with the outside world. Although they were able to handle the gliders used during their first three visits to the Outer Banks themselves, crewmen from the neighboring stations kept tabs on what the brothers were doing. In 1903, the powered flyer was too much for the Wrights to handle alone, so men from the Kill Devil Hills station served as ground crew. John Daniels, a surfman, took the famous photograph of Orville's first flight after being instructed on the use of the camera by Wilbur. According to Daniels, it was the first and last photograph he ever took.

The Life-Saving Service legacy lives on in other ways. Two distinctive architectural styles were introduced to the Outer Banks through station designs drawn by government architects. The first, based on the Victorian Gothic stick-built vernacular, incorporated decorative board-and-batten siding, king posts, outlooks or towers perched on steep roofs, peaked window framing reminiscent of Gothic cathedrals, and other details not found in Outer Banks buildings at that time.

Stations built later in the program were less ornate and better suited to the harsh coastal environment. They featured lower-pitch roofs with wide eaves but taller enclosed lookout towers, simple square window framing, and shingle siding. The distinctive details of both styles serve as the basis for many of the homes built here today.

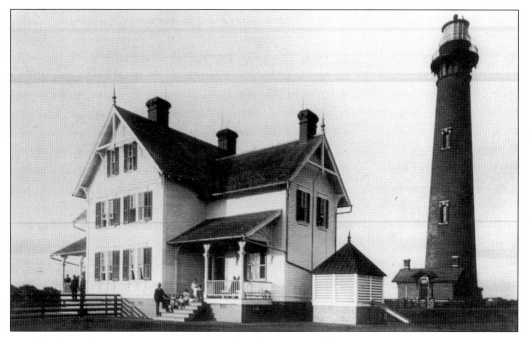

CURRITUCK BEACH LIGHT STATION. This photograph of the Carpenter Gothic-style double keepers' house was taken a few years after the building was completed in 1876. Two keepers split shifts to keep the light burning for 12 hours each night until an automatic beacon was installed in 1939. The house, still in its original location, has been restored. (Courtesy of Willard E. Jones, date unknown.)

CURRITUCK BEACH LIFE-SAVING STATION. The station, originally called Jones Hill, was established in 1874. This Quonochontaug-type building was built in 1903. It was moved north to Pennys Hill in the 1980s, where it still serves as a private residence. (Courtesy of Hank Frazier, date unknown.)

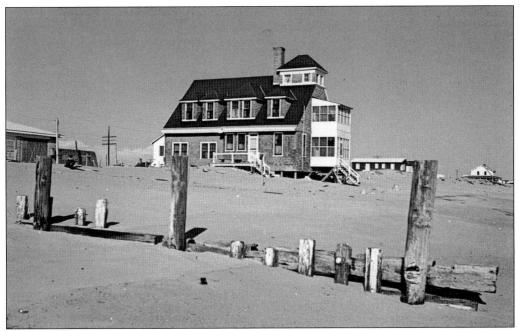

KITTY HAWK LIFE-SAVING STATION. In 1911, this Chicamicomico-style station at Kitty Hawk replaced a smaller Gothic Revival building built in 1874. It was in service until 1937 and currently serves as a private residence near its original location on the beach road. (Courtesy of Michael G. Tames, date unknown.)

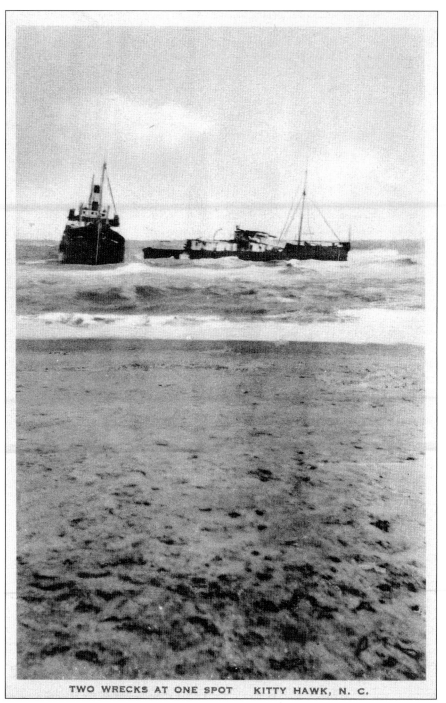

TWO WRECKS AT ONE SPOT KITTY HAWK, N. C.

WRECKS OF THE *CARL GERHARD* AND THE *KYZIKES*. The Swedish steamer *Carl Gerhard* and the Greek tanker *Kyzikes* (also called the *Paraguay*) lie together near the beach at Kill Devil Hills. The tanker broke up during a storm in 1927 and drifted ashore. The steamer ran aground on the bar in 1929. Crews of both ships were saved by surfmen from nearby stations. (Courtesy of Michael G. Tames, 1930s.)

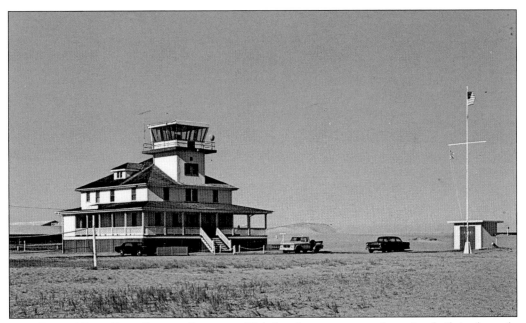

KILL DEVIL HILLS LIFE-SAVING STATION. This Southern pattern–style station built in the early 1900s replaced a 1870s Gothic Revival building. The old building, still in service when its crew helped the Wright brothers fly on December 3, 1903, was used as a boathouse when the new station opened. It was later sold and used as a gift shop in Corolla. (Courtesy of Michael G. Tames, 1950s.)

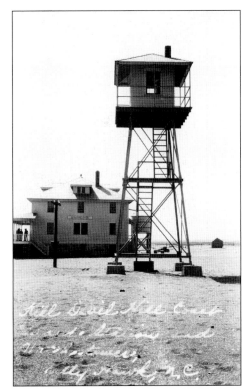

KILL DEVIL HILLS LIFE-SAVING STATION. This is an earlier photograph of the station shown above, taken before the observation tower was added to the building. This station was in service until 1964, when ownership reverted to the original owners of the land. The building was torn down in 2004 to make room for new houses. (From the collections of the Outer Banks History Center, 1930s.)

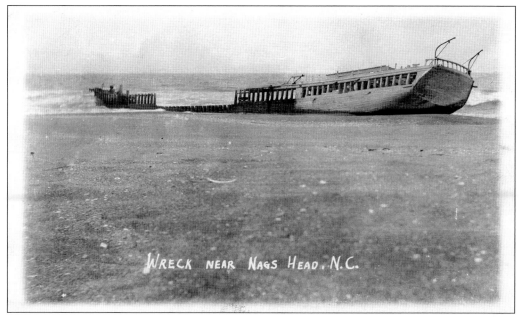

WRECK OF THE *IRMA*, NEAR NAGS HEAD. This schooner wrecked off the Kill Devil Hills shore in 1925. It was one of 22 documented wrecks along the Outer Banks in the 1920s, most of them sailing schooners. (From the collections of the Outer Banks History Center, date unknown.)

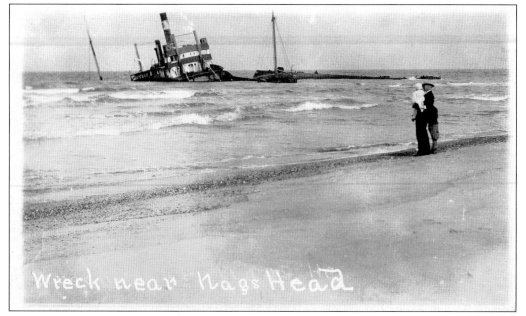

WRECK NEAR NAGS HEAD. This wreck is probably the *Carl Gerhard*, whose crew was assisted by surfmen from four nearby Coast Guard stations, including, perhaps, Nags Head, which was in service from 1874 until 1957. The original station, built in 1874, and its 1912 replacement are no longer standing. (From the collections of the Outer Banks History Center, 1930s.)

SCREW-PILE LIGHTHOUSE. This photograph may show the Croatan Lighthouse, built in 1866 to mark the channel at the northern end of Croatan Sound. More likely, it is the nearby Wade's Point Lighthouse that marked the mouth of the Pasquotank River. Both gone, they were similar to the Roanoke Marshes Light, a replica of which now stands on the Manteo waterfront. (From the collections of the Outer Banks History Center, *c.* 1920.)

WRECK OF THE *LAURA BARNES*, NEAR NAGS HEAD. This publicity shot shows two local men playing pirate in front of what remains of the *Laura Barnes*, one of the last coastal schooners. She ran aground at Bodie Island during a foggy nor'easter in 1921. The National Park Service moved the wreck to its present location at Coquina Beach. (From the collections of the Outer Banks History Center, 1963.)

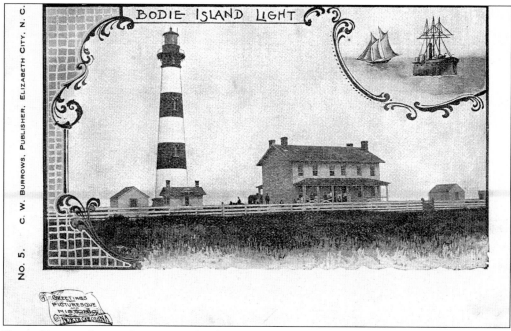

BODIE ISLAND LIGHT STATION. The first Bodie Island Lighthouse began service in 1848 but was almost immediately declared unfit because of poor construction. A second tower, built in 1858, was blown up three years later by Confederate forces. The current 150-foot tower, shown here, was built in 1872. (Courtesy of Michael G. Tames, *c.* 1900.)

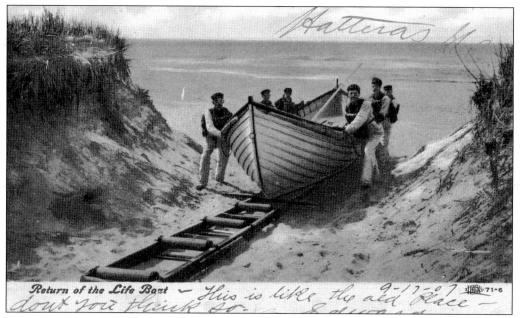

RETURN OF THE LIFE BOAT. Surfboats used by lifesavers were about 27 feet long, 7 feet wide, and weighed as much as 1,100 pounds. They could carry a dozen passengers plus crew. The boats were stored on four-wheel carts that could be pulled to the water for launching. Portable wooden tracks assisted both the launch and the return. (Courtesy of Willard Jones, 1907.)

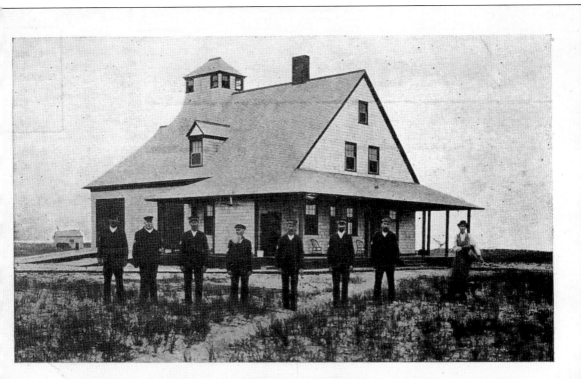

Oregon Inlet, N. C., Life Saving Station and Crew.

QUONOCHONTAUG-STYLE LIFE-SAVING STATION. Although identified by sources as both New Inlet and Oregon Inlet Life-Saving Stations, this postcard matches existing records of neither station. It may be Currituck Beach Station. In any case, it demonstrates the characteristics of its style—one-and-a-half story, shingled, frame construction with a hip-roofed watchtower, wrap-around porch and an integrated boat room—patterned after a station first built at Charlestown, Rhode Island, in 1892. (Courtesy of Michael G. Tames, 1931.)

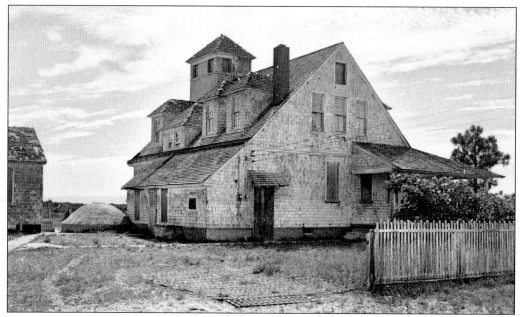

CHICAMICOMICO LIFE-SAVING STATION. Built in 1911, this building was a new shingle-style design adapted from the Quonochontaug style of earlier stations. It replaced the station's 1874 Gothic-style quarters, which were converted to a boathouse. The station operated until 1954. Both buildings have been restored and serve as a Life-Saving Service museum. (Courtesy of Willard E. Jones, 1970s.)

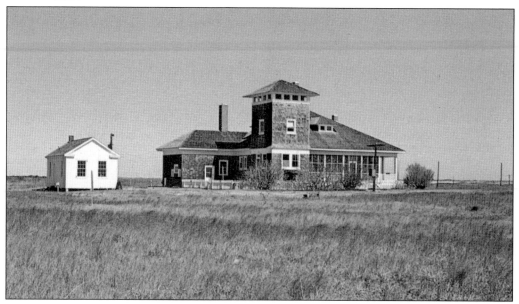

LITTLE KINNAKEET LIFE-SAVING STATION. This station was in service from 1874 to 1954, although it was not used for a few years during World War II. The bungalow-style building shown here was built in 1904, replacing the station's original 1874 Gothic-style building, one of the first seven life-saving stations built along the North Carolina coast. (Courtesy of Willard E. Jones, 1960s.)

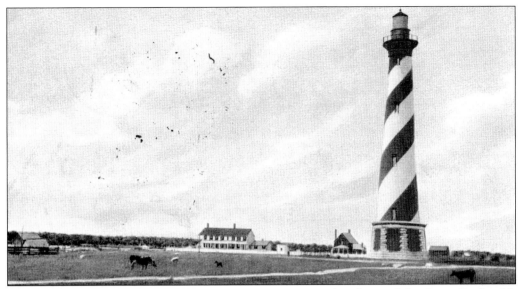

CAPE HATTERAS LIGHT STATION. Located in Buxton, at the elbow of the Outer Banks, this lighthouse has been a landmark since the first tower was built in 1802. The rest of the station has looked much the same, except for a brief period in the late 1950s when the keeper's quarters, built in 1854, and other buildings were painted pastel blue and pink. (Courtesy of Michael G. Tames, 1911.)

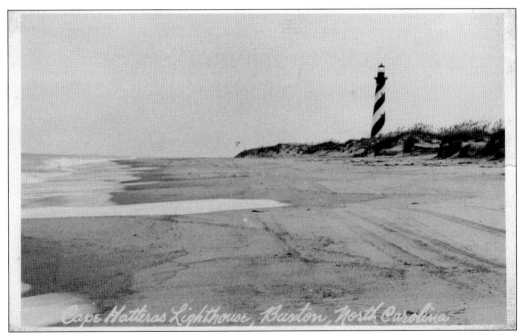

CAPE HATTERAS LIGHTHOUSE. The first lighthouse, constructed of sandstone, stood 90 feet tall until it was raised 50 years later to 150 feet. Still not adequate for the job, it was replaced by a new 208-foot brick tower in 1870. The old tower was torn down the following year. In 1999, shoreline erosion prompted the National Park Service to move the entire station 2,900 feet to the southwest. (Courtesy of Michael G. Tames, 1955.)

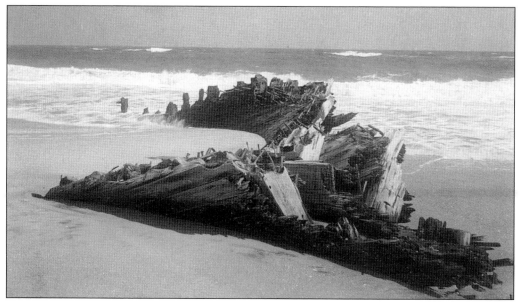

WRECK OF THE *G.A. KOHLER*. The *Kohler*, one of the last four-masted sailing ships working the Atlantic Coast, grounded during a hurricane south of Salvo in 1933. The crews from Gull Shoal and Chicamicomico Life-Saving Stations rescued nine people on board before storm tides finally beached the ship. The hull was burned in the 1940s to recover scrap metal. (Courtesy of Michael G. Tames, 1957.)

WRECK OF THE *CARROLL A. DEERING*. This five-masted schooner ran aground at Diamond Shoals in 1921. Her sails set and her lifeboats gone, no trace was ever found of the crew that apparently abandoned her. Parts of the ship eventually washed up at Ocracoke and, later, at Hatteras, where one enterprising gas station owner set up this display to attract business. (Courtesy of Willard E. Jones, date unknown.)

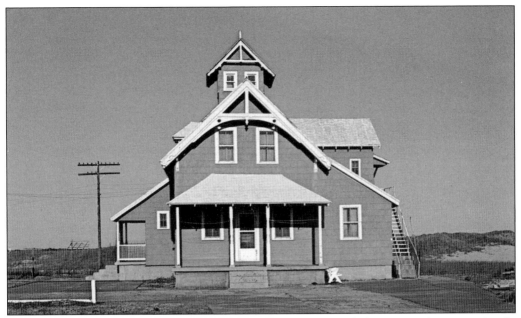

DURANTS LIFE-SAVING STATION. This station, originally called Hatteras, began service in 1878. It was decommissioned in 1937, eventually sold and renovated as part of the Durants Station motel in Hatteras Village. Hurricane Isabel destroyed the building in 2003. (Courtesy of Willard E. Jones, date unknown.)

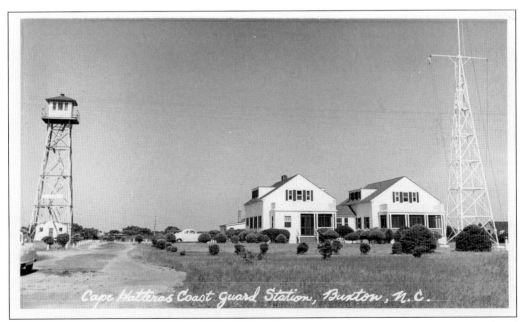

CAPE HATTERAS COAST GUARD STATION. These buildings, built in 1940 at Buxton, replaced an 1882 life-saving station located closer to the beach. The National Park Service took over the buildings in 1985. (Courtesy of Michael G. Tames, 1940s.)

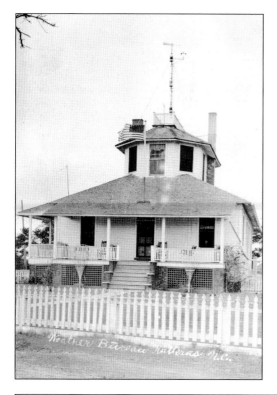

HATTERAS WEATHER BUREAU. Built in 1901 in Hatteras Village, this was the first independent weather bureau site in the United States. Previously, weather station employees had shared space with other federal services. It operated as a weather station until the late 1950s, when the bureau moved to Buxton. The National Park Service has restored the building. (Courtesy of Michael G. Tames, 1941.)

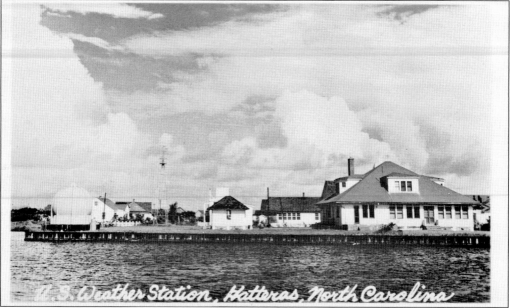

U.S. WEATHER STATION AT HATTERAS. Although this postcard is clearly labeled, its accuracy is questionable. The main building in the photograph is the Hatteras Girls' Club built in the 1930s. Island historians say that if the weather station moved within the village, which they doubt, it would have been right before the move to Buxton in the 1950s, years after this card was published. (Courtesy of Michael G. Tames, 1940s.)

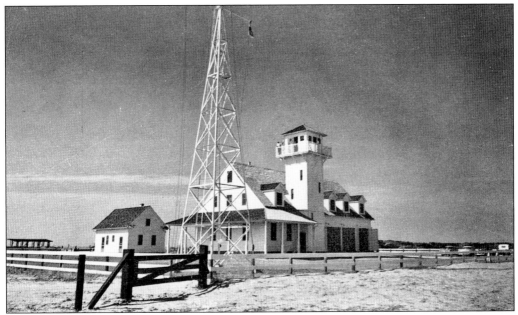

OREGON INLET LIFE-SAVING STATION. This Quonochontaug-style building replaced the original station on the south side of Oregon Inlet in 1898. It was called Bodie's Island until 1883, when the name was given to another station. The station was used until 1988, when erosion forced the Coast Guard to relocate north of the inlet. (From the collections of the Outer Banks History Center, 1957.)

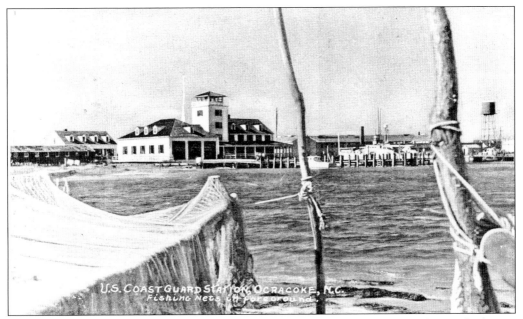

OCRACOKE COAST GUARD STATION. The first life-saving station at Ocracoke was built near Hatteras Inlet in 1882. The station shown on this postcard replaced a second station, built in the village on Cockle Creek in 1904. Completed in 1940, the building is still standing in its original location. (From the collections of the Outer Banks History Center, *c.* 1950.)

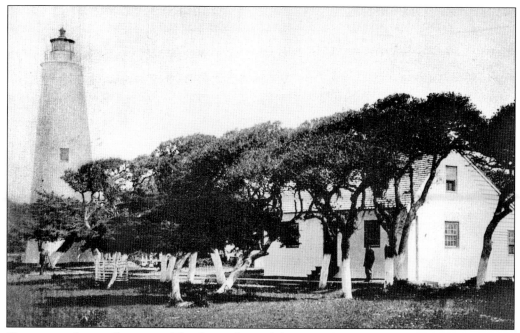

OCRACOKE LIGHT STATION. The Ocracoke Lighthouse and its keeper's quarters were built in 1823. The 65-foot tower is the oldest operating lighthouse in North Carolina and the shortest of the tower-type beacons on the Outer Banks because, marking inland water, it was intended to be viewed at relatively short distances. (Courtesy of Willard E. Jones, *c.* 1920.)

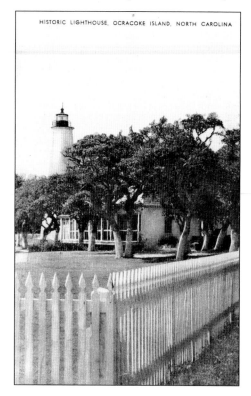

HISTORIC LIGHTHOUSE, OCRACOKE ISLAND, NORTH CAROLINA

OCRACOKE LIGHT STATION. First plans for a lighthouse at Ocracoke Inlet, a crucial Colonial waterway, were made in 1790. One acre of land was given to the state by island residents for its construction. Plans changed when the federal government assumed responsibility for all navigational beacons and built a lighthouse at Shell Castle Island instead. (From the collections of the Outer Banks History Center, date unknown.)

Eight
MAKING THE TRIP

Traveling to the Outer Banks has never been easy. More than 400 years ago, English explorers were complaining about the trip. David Beers Quinn, in his book Set Fair for Roanoke, *quotes the account of Col. Ralph Lane after the* Tiger, *flagship of Sir Richard Grenville's 1585 fleet, grounded on the Outer Banks: "The Tiger lying beating upon the shoal for the space of two hours by the dial, we were all in extreme hazard of being cast away, but in the end, by the mere work of God, floating off, we ran her aground hard to shore, and so with great spoil of our provisions saved ourselves."*

In 1728, William Byrd set out to survey the dividing line between North Carolina and Virginia. Near Knotts Island, "We found this navigation very difficult, by reason of the continued shoals, and often struck fast aground. . . . It was almost as hard to keep our temper as to keep the channel," wrote Byrd, quoted in David Stick's Outer Banks Reader. *"We were stopped by a miry pocosin full half a mile in breadth," he continued, "through which we were obliged to daggle on foot, plunging now and then . . . up to our knees in mud." Tongue in cheek, Byrd called it a "charming walk."*

Edward R. Outlaw Jr. reported on travel conditions to and from the Outer Banks in 1882 in his book, Old Nag's Head. *His own family traveled by chartered boat from Bertie County to Nags Head to Kinnakeet (Hatteras Island). "On the voyage . . . there was considerable discomfort from seasickness," he wrote. "Prayer was offered frequently."*

By the end of the 19th century, a small community of hardy souls lived at Nags Head Woods. Their transportation of choice was small skiffs that could navigate the creeks and marshes on the sound side of the island. Horse-drawn carts were less favored among locals but were popular with tourists and families who owned summer cottages.

Wilbur Wright left an account of his first passage to Kitty Hawk that may have been typical of the times. He hired a local fisherman, Israel Perry, to carry him and his sizeable pile of luggage and lumber from Elizabeth City to Kitty Hawk. They had to take a skiff from the docks to Perry's fishing vessel, the Curlicue, *anchored three miles down river. "The [skiff] leaked very badly and frequently dipped water, but by constantly bailing we managed to reach the schooner in safety," wrote Wilbur in his journal. "The strain of rolling and pitching sprang a leak and this, together with what water came over the bow at times, made it necessary to bail frequently." The* Curlicue, *he wrote, "was in worse condition if possible than the skiff. The sails were rotten, the ropes badly worn and the rudder post half-rotted off, and the cabin so dirty and vermin-infested that I kept out of it from first to last."*

The weather had been fair with a light wind when Perry set out with his not-yet-famous passenger, but it soon deteriorated as the remnants of a hurricane swept through the area. The Curlicue sailed downstream after dinner toward the Albemarle Sound, where the water proved to be much rougher. The wind increased and shifted, making progress difficult. "The waves which were now running quite high struck the boat from below with a heavy shock and threw it back about as fast as it went forward. The leeway was greater than the headway," Wilbur wrote. It took more than four hours to travel less than 12 miles down the Pasquotank River, and the boat was damaged.

It was mid-afternoon the following day before damage to the boat and sails was repaired and the Curlicue got underway again. They arrived at Kitty Hawk, a fair walk from Tate's house, after dark, so the men remained aboard the boat until morning. It had taken Wilbur nearly twice as long to travel from Elizabeth City to Kitty Hawk than from Dayton, Ohio, to Elizabeth City.

For three years beginning in 1901, the Wrights camped at the base of Kill Devil Hill some four miles south of Kitty Hawk Village. The trip to the village was a time-consuming slog through soft sand to the shore of Kitty Hawk Bay, where they could follow the hard-packed shoreline. In 1902, they brought a bicycle modified for riding through sand, which, they claimed, cut a couple hours off the trip.

It is interesting to note that the Wrights were flying around Kill Devil Hills years before the first automobiles arrived. The first motorcar was reported at Nags Heads in 1917. It arrived by boat, of course, since the first bridge from the mainland was not built until 1930. In his history of Dare County, David Stick sums up the introduction of motorized transportation: "Power boats came first, then automobiles."

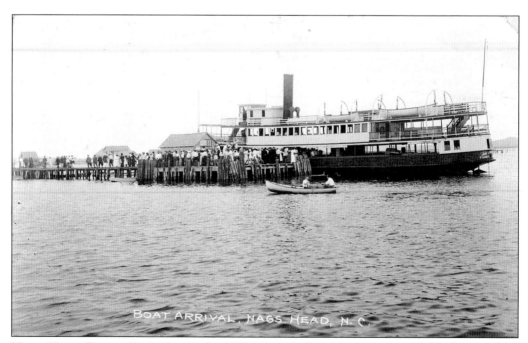

NAGS HEAD DOCK. Beginning in the 1850s, years before Manteo was established, steamships made regular trips during summer months from Norfolk to Nags Head. Soundside hotels offered rides to the beach on horse-drawn railroad cars. (Courtesy of Michael G. Tames, 1914.)

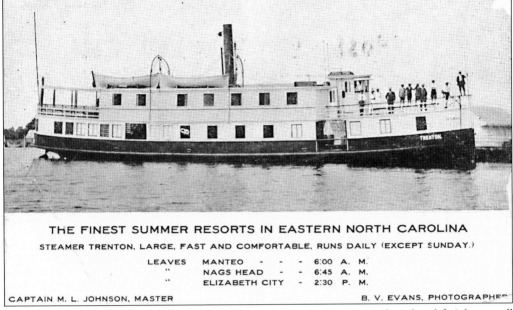

THE FINEST SUMMER RESORTS IN EASTERN NORTH CAROLINA

STEAMER TRENTON, LARGE, FAST AND COMFORTABLE, RUNS DAILY (EXCEPT SUNDAY.)

LEAVES	MANTEO	- - -	6:00 A. M.
"	NAGS HEAD	- -	6:45 A. M.
"	ELIZABETH CITY	-	2:30 P. M.

CAPTAIN M. L. JOHNSON, MASTER B. V. EVANS, PHOTOGRAPHER

THE *TRENTON*. Beginning in 1914, this locally owned steamship carried mail and freight as well as passengers from Elizabeth City to Manteo with summer stops in Nags Head. Before the *Trenton* and the dredging of a deeper channel at Shallowbag Bay, the steamship *Neuse* brought passengers and freight to Skyco on its run between Elizabeth City and New Bern. (From the collections of the Outer Banks History Center, date unknown.)

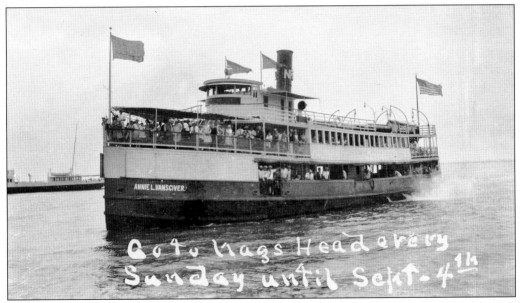

THE *ANNIE L. VANSCIVER*. Steamships kept running even after bridges, ferries, and roads connected the beach to the mainland. The *Vansciver* was one of the last to make the summer trip, leaving Elizabeth City for Nags Head in the morning, returning the same evening. For a couple summers, it also stopped at Virginia Dare Shores on Kitty Hawk Bay. (From the collections of the Outer Banks History Center, 1937.)

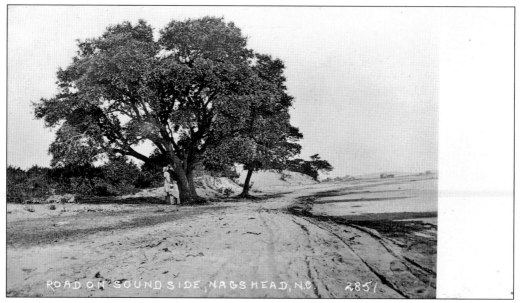

NAGS HEAD ROAD. Before paved roads, locals traveling from one place to another walked or rode along the shore whenever possible. These tracks along the Roanoke Sound at Nags Head are probably in the vicinity of today's Soundside Road. The smaller dunes in the background may be part of the old Seven Sisters system that ran south of Jockey's Ridge. (Courtesy of Hank Frazier, *c.* 1915.)

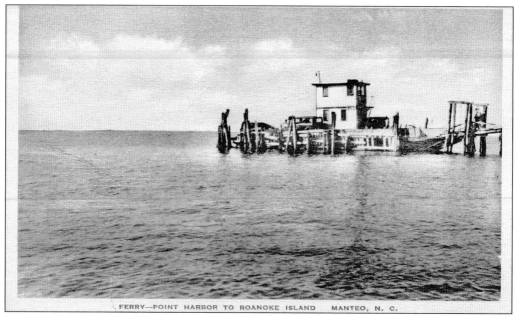

POINT HARBOR–ROANOKE ISLAND FERRY. Automobiles came to the Outer Banks before bridges, and privately owned toll ferries provided the first links from mainland roads to the barrier islands. This ferry ran from Point Harbor on the Currituck mainland to the north end of Roanoke Island. The same company also operated a ferry from Point Harbor to Kitty Hawk. (Courtesy of Michael G. Tames, 1920s.)

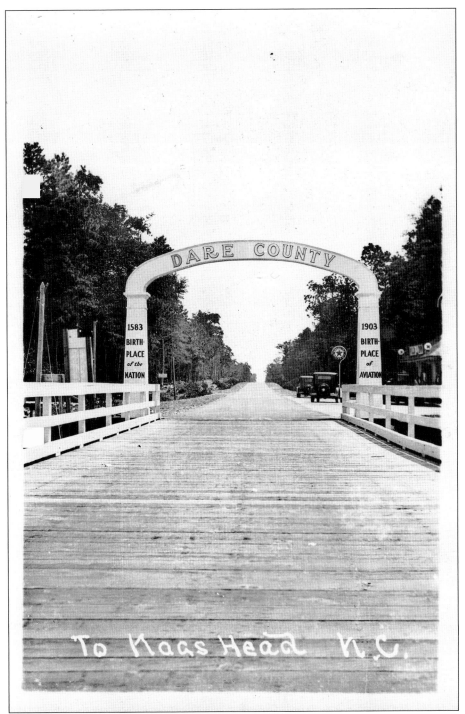

WRIGHT MEMORIAL BRIDGE. The first bridge across the Currituck Sound opened in 1930. The three-mile long, wood plank toll bridge was owned by a group of Albemarle-area investors. The attractive arches at either end of the bridge had to be removed because delivery trucks could not fit through them. (Courtesy of Willard E. Jones, *c.* 1931.)

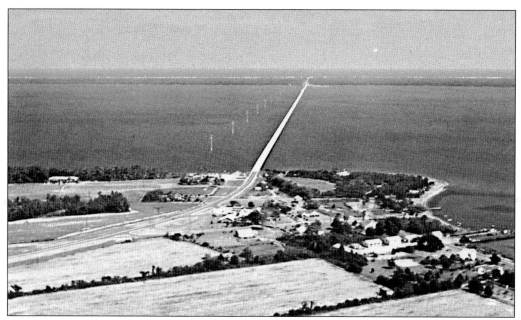

WRIGHT MEMORIAL BRIDGE. In the 1930s, the state built an asphalt road down the beach, connecting this bridge, shown looking east, to the privately owned Roanoke Sound Bridge and, eventually, bought both bridges. Although there were a few houses on the oceanfront in Nags Head, construction of the beach road marked the beginning of oceanfront development along the rest of its 18 miles. (From the collections of the Outer Banks History Center, *c.* 1960.)

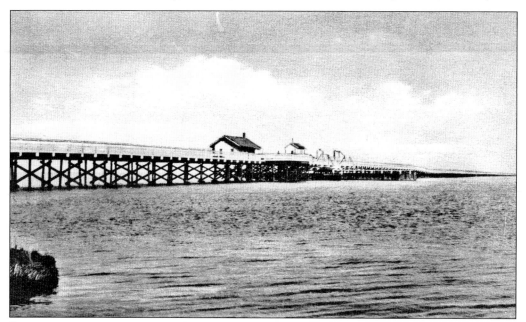

ROANOKE SOUND BRIDGE. Built in 1927 with county funds, this toll bridge was the first bridge on the Outer Banks—and, as of 2004, the first of three bridges to be built at this location. At the time, the only paved road ran between Manteo and Wanchese. The causeway was dirt; the beach roads were sand. (From the collections of the Outer Banks History Center, *c.* 1930.)

MANTEO–NAGS HEAD CAUSEWAY. The original causeway was created with dirt dredged from the ditches and harbor that still line the roadway. Three years later, the state took over the road and paved it with asphalt made at a plant set up at Jockey's Ridge. The toll was discontinued. (Courtesy of Michael G. Tames, *c.* 1930.)

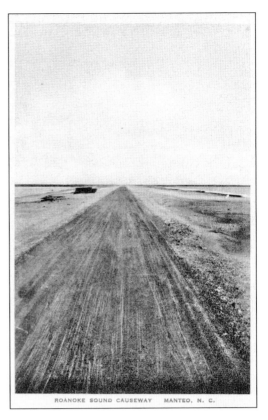

ROANOKE SOUND CAUSEWAY MANTEO, N. C.

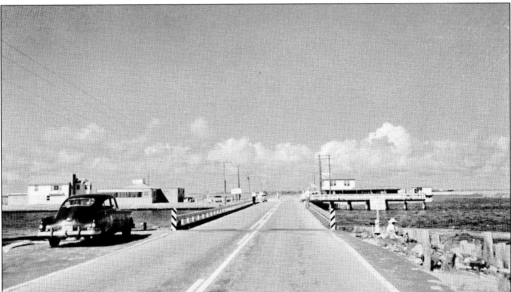

MANTEO–NAGS HEAD CAUSEWAY. By the 1950s, the causeway had become a popular fishing and crabbing spot. A couple of small fishing piers, bait shops, gas stations, and restaurants lined what is still the only link between Roanoke Island and the beach. The Oasis and Reef restaurants can be seen down the road. (From the collections of the Outer Banks History Center, *c.* 1955.)

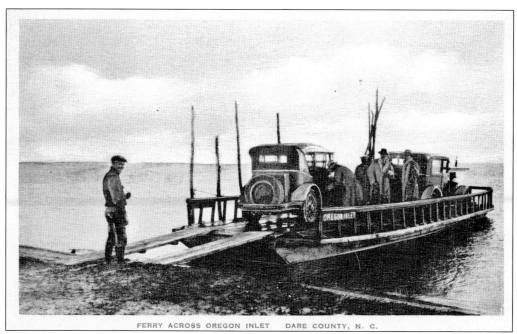

FERRY ACROSS OREGON INLET DARE COUNTY, N. C.

OREGON INLET FERRY. For over 30 years before the highway on Hatteras Island was paved, ferries carried drivers across the inlet, where they took off across the sand in any direction they pleased. This ferry, operated by Jennings Bryant "Toby" Tillett, was a two-car barge pulled by motorboat. The state bought Tillett's ferry in the 1950s and operated the service until a bridge was opened in 1963. (Courtesy of Michael G. Tames, *c*. 1925.)

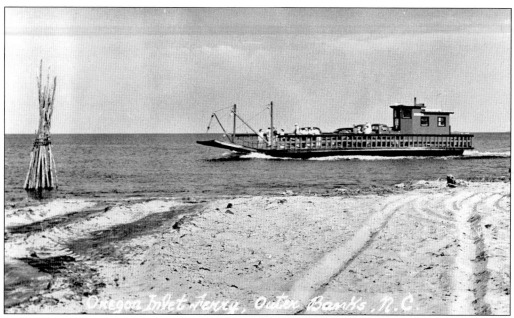

OREGON INLET FERRY. By the time the state took over ferry service at Oregon Inlet, Tillett had replaced his barge with a larger, motor-driven ferry. (From the collections of the Outer Banks History Center, date unknown.)

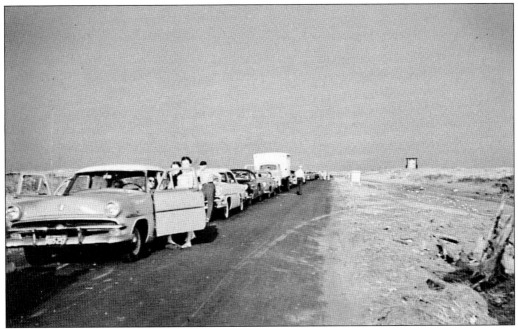

WAITING FOR THE OREGON INLET FERRY. Drivers wait on the newly paved Hatteras highway at Pea Island for the Oregon Inlet ferry. (From the collections of the Outer Banks History Center, *c.* 1955.)

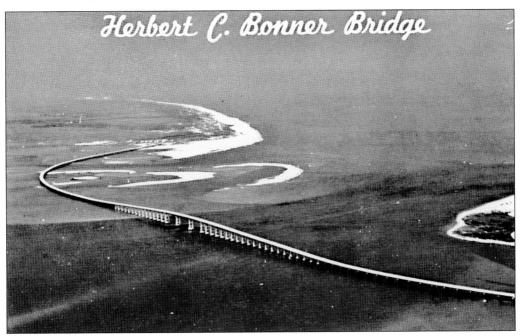

HERBERT C. BONNER BRIDGE. This view looks north over the 2.5-mile span. Bodie Island Lighthouse is center left. The bridge's 100-foot crest over Oregon Inlet provides views that take in Pea Island, the southern end of Roanoke Island, and South Nags Head. (From the collections of the Outer Banks History Center, *c.* 1966.)

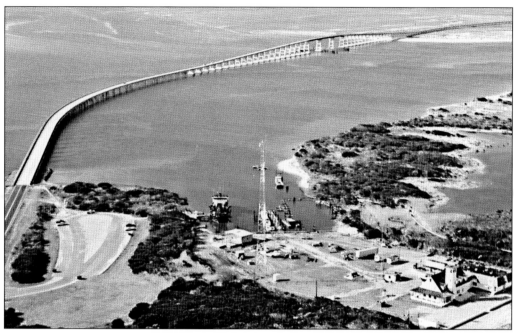

HERBERT C. BONNER BRIDGE. The former Oregon Inlet Coast Guard Station is in the foreground of this view looking northwest. Severe erosion threatened the station, which closed the year this photograph was taken. In 2004, the buildings were abandoned but still standing. (Courtesy of Jim Lee, from the collections of the Outer Banks History Center, *c.* 1988.)

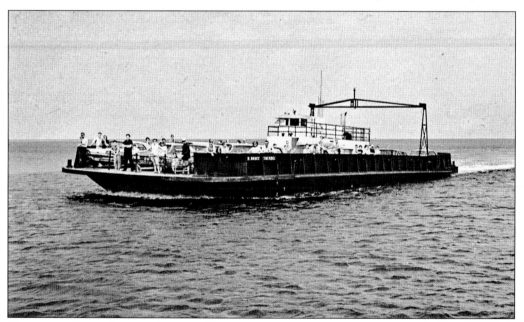

HATTERAS INLET FERRY. Private toll service across Hatteras Inlet began after World War II. The state bought the business in 1957. The free 45-minute ferry ride from Hatteras Village to the docks at the north end of Ocracoke Island is a tourist attraction in itself, drawing thousands of riders on busy summer days. (From the collections of the Outer Banks History Center, *c.* 1962.)

Nine
ROOM WITH A VIEW

The summer seashore, with its salt breezes and access to water, has been the Outer Banks' primary drawing card for generations. Beginning before the Civil War, wealthy farmers and businessmen sent their families to the coast to escape the South's muggy season. These early visitors brought servants, livestock, and boatloads of supplies to set up housekeeping in soundside cottages.

After the war, the summer people began moving to the oceanfront. Generations repeated the annual summer-long visits until a changing economy and social customs shortened the stays and opened the beaches to people from all walks of life.

The vacation, as we know it today, is a post–World War II by-product of industrialization. For the first time, the average American was being told to take time off and relax. Workers had their weekends, paid vacations, or, at least, the opportunity to be away without losing their jobs. By the end of the 1940s, highways put the barrier islands within easy reach of Tidewater Virginia and points north along the eastern seaboard to New York.

It's a fact: given a vacation, a good number of people want to go to the beach. Beaches north of the Outer Banks, closer to population centers and more easily accessible, had been crowded to capacity on weekends and holidays for decades. Given a choice, people wanted to get away from crowds, noise, pollution, and artificial landscapes.

The Outer Banks was ready to fill the bill, and the people came. Thanks to the efforts of the Outer Banks Visitors Bureau, National Park Service, Outer Banks Chamber of Commerce, North Carolina Department of Tourism, and other agencies and organizations, by the year 2000, more than 225,000 visitors could be found on the Outer Banks on most July or August days.

Unlike the summer folk of earlier eras, whose families owned their cottages at the beach, most of the new visitors needed places to stay. The evolution of accommodations on the Outer Banks is a study of how lifestyles have changed over the last 100 years. Much of it has been documented in the postcards sent from the beach.

The first hotels on the barrier islands, at Nags Head and Ocracoke, were bastions of gentility. Staff opened doors, carried luggage, and served drinks. Men and women dressed for dinner in the hotel dining rooms. Parlors and covered porches provided opportunities for polite conversation and card games. Live music and other entertainments were offered.

By the 1950s, many vacationers were looking for something else. Arriving by car, they wanted the new convenience of parking at their doors. They were not looking to socialize with strangers. They wanted to carry

their own bags, do their own thing, and eat wherever they wanted dressed as they pleased. Dare County accommodations followed the national trend toward park-at-your-door motor courts.

Early beach motels offered few creature comforts. Built for summer use, most had no heat. It was not until the 1960s that guests could find rooms with air conditioning, telephones, and televisions. Through the 1970s, most remained independent, family-run operations.

At the same time, land developers realized that many visitors would like to own a home at the beach, just as the previous generations of summer people had done. Southern Shores, Colington Harbor, Avalon Beach, and other developments began promoting vacation home ownership and the notion of using seasonal rentals to offset the cost of owning a second home. The vacation housing market has grown beyond the scope of this book. The average second home has grown, too—from small, 800-square-foot beach boxes built for families of four to 8,000-square-foot mansions meant to accommodate extended family groups of 20 or 30.

This progression, from the lodges and summer cottages of well-to-do visitors to motels and beach cottages for working-class vacationers to today's vacation homes, applies primarily to the northern Dare County beaches.

On the Currituck Banks, many years passed after the era of hunting lodges before an accommodations market developed—and then it was limited to second homes and rental cottages. Although one or two bed-and-breakfast inns opened before 2000, the first commercial hotel did not open at the Currituck beach until later.

Hatteras Island never had an era of grand hotels as Nags Head did. Its first accommodations were hunting and fishing lodges. From there, the island's entrepreneurs jumped directly into the motel business. More upscale accommodations came later.

Ocracoke, like Nags Head, was a favorite for summer people in the late 1800s. Harbor-side hotels thrived until the automobile ended the steamboat era. Vacationers began rediscovering the island in the 1960s, but Ocracoke accommodations stayed low key.

Manteo, as a permanent community, had hotel and rooming-house accommodations year-round from the time it became county seat in 1870. As local businesses can attest even today, court sessions create customers for all sorts of services, including a hot shower and a good night's sleep.

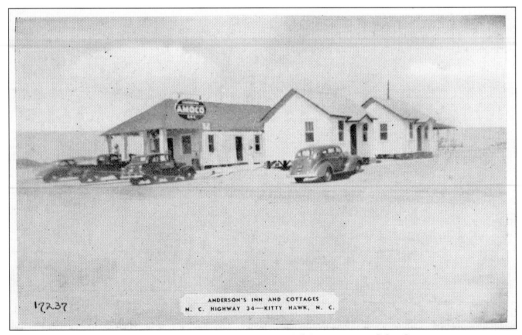

ANDERSON'S INN AND COTTAGES, KITTY HAWK. This was one of the first cottage courts on the beach. Located just south of the Kitty Hawk Pier, it was destroyed in the Ash Wednesday Storm of 1962. (Courtesy of Michael G. Tames, c. 1937.)

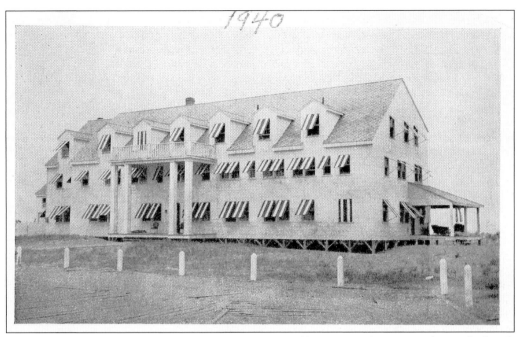

WILBUR WRIGHT HOTEL, KILL DEVIL HILLS. Located between mileposts 8 and 9 on the beach road, this hotel was destroyed by a tornado in 1980. (Courtesy of Michael G. Tames, 1940.)

SUN 'N SAND MOTEL, KILL DEVIL HILLS. This was one of dozens of small mom-and-pop motels that had opened along the beach road by the early 1950s. It offered at-your-door parking, "reasonable rates," and private baths. (Courtesy of Michael G. Tames, 1953.)

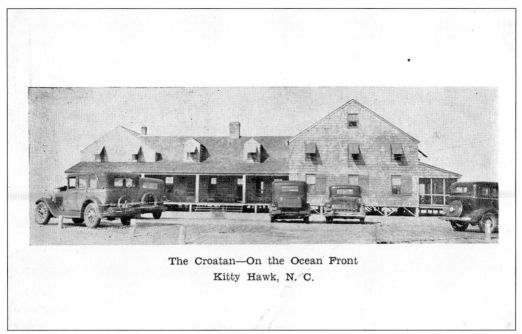

The Croatan—On the Ocean Front
Kitty Hawk, N. C.

CROATAN HOTEL, KILL DEVIL HILLS. This was the first hotel built north of the Wright monument after the beach road was paved. Still at its original location on the beachfront at milepost 7.5, the old inn is now known as Quagmires, a popular restaurant and bar. (Courtesy of Willard E. Jones, date unknown.)

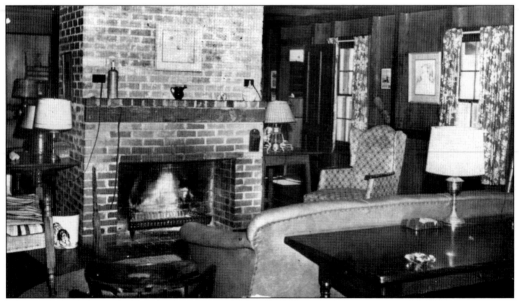

CROATAN HOTEL, KILL DEVIL HILLS. The Croatan was an upscale accommodation in its day, featuring a club-like ambience, terrace dining, and a social hour on the sun deck. (From the collections of the Outer Banks History Center, date unknown.)

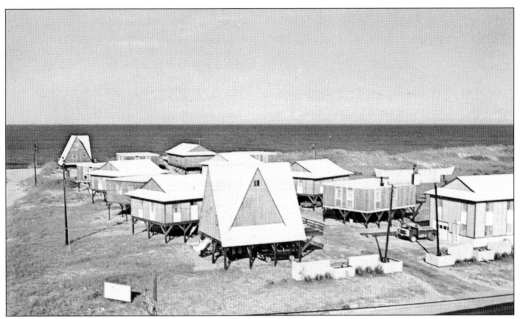

NAGS LANTERN COTTAGES, KILL DEVIL HILLS. Located one mile south of the Wright monument on the oceanfront, the unusual architecture of these cottages was replaced in the 1970s by buildings just as remarkable: the round towers of the Outer Banks Beach Club. (Courtesy of Michael G. Tames, 1960s.)

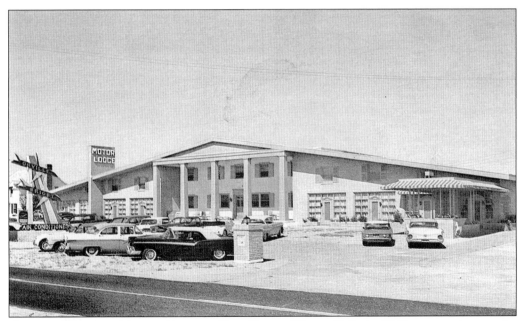

ORVILLE WRIGHT MOTOR LODGE, KILL DEVIL HILLS. Built in 1948 to complement the adjacent Wilbur Wright Hotel (see page 91), it featured exposed hardwood beams and a stonework fireplace more commonly found in mountain inns. In the 1960s, it offered air-conditioned rooms and 24-hour room service. It is still open for business, as the Wilbur & Orville Wright Days Inn. (Courtesy of Michael G. Tames, 1960s.)

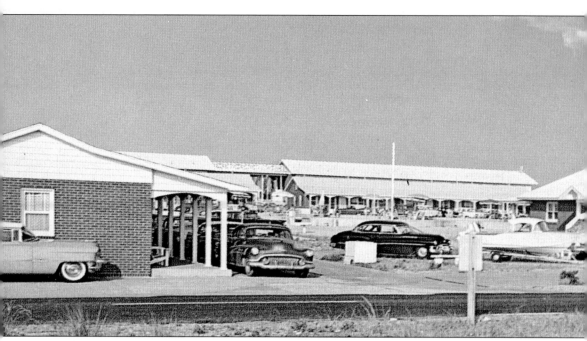

CAVALIER MOTEL, KILL DEVIL HILLS. When opened in 1950, the Cavalier billed its 19 rooms as the most modern on the beach. By the 1960s, co-owner Roy Westcott Sr. offered 54 rooms, open all year, each with its own air conditioning and steam heat thermostat and tile tub-and-

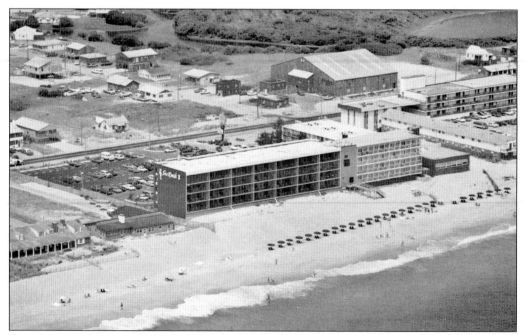

SEA RANCH, KILL DEVIL HILLS. The beach at this well-known hotel looks inviting in this photo, probably taken in the late 1970s. Just a few years later, it was severely eroded. The hotel and its adjacent timeshare building both suffered damage in several storms during the 1980s and 1990s but are still in operation. (Courtesy of Michael G. Tames, date unknown.)

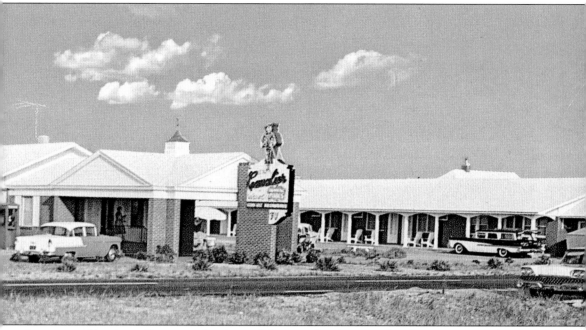

shower combinations. Guests got free ice and the use of a playground and swimming pools. The Cavalier is still open at milepost 8.5. (Courtesy of Michael G. Tames, 1960s.)

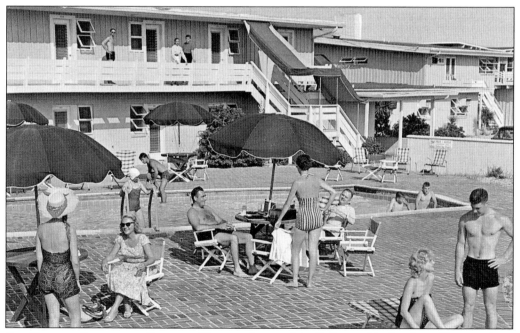

SEA RANCH, SOUTHERN SHORES. The motel was originally located in Southern Shores, where this photograph was taken. Severely damaged in the Ash Wednesday Storm, the motel was rebuilt by owner Alice Sykes at milepost 7 in Kill Devil—a location that, ironically, has proved no less hazardous. (Courtesy of Michael G. Tames, 1961.)

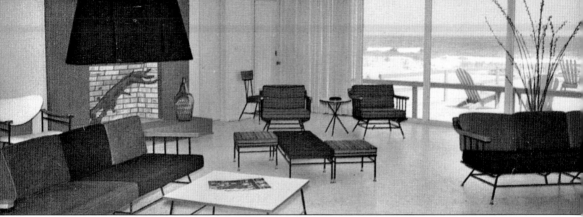

OCEAN HOUSE MOTEL, KILL DEVIL HILLS. Following the example set by the Cavalier, the 40-unit oceanfront Ocean House offered stylish accommodations with air conditioning, heat, and

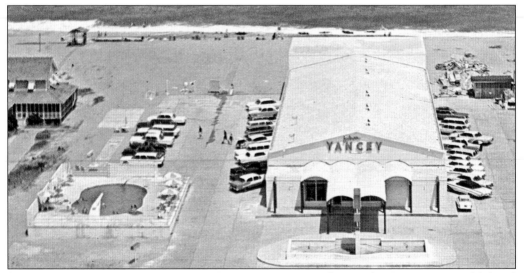

JOHN YANCEY MOTOR HOTEL, KILL DEVIL HILLS. Next door to the Ocean House, this hotel offered rooms with television, telephones, and Westinghouse air conditioning in 1964. Facilities at that time included a 300-seat convention hall, Playhouse Theater, Celebrity Dining Hall, a private club, and a badminton court. The swimming pool had a waterfall. (Courtesy of Michael G. Tames, 1964.)

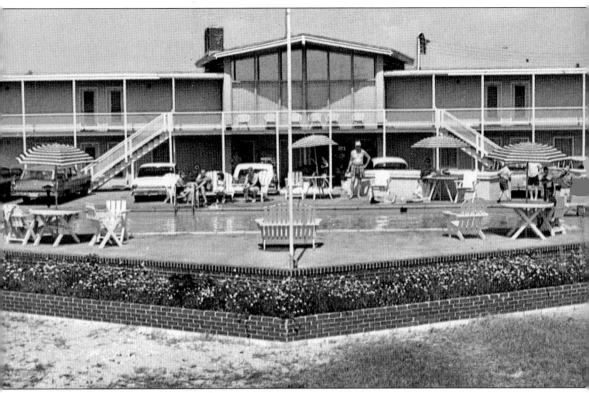

a large swimming pool. The motel is still in business at milepost 9.5. (Courtesy of Michael G. Tames, 1960s.)

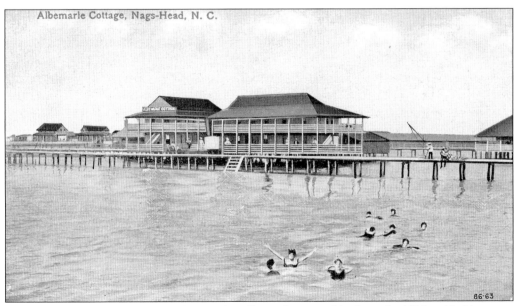

Albemarle Cottage, Nags-Head, N. C.

86-63

ALBEMARLE COTTAGE, NAGS HEAD. The Albemarle opened in the early 1900s with 24 rooms. It was built over the water next to the soundside boat docks. A nor'easter in 1932 destroyed the building. (Courtesy of Willard E. Jones, 1919.)

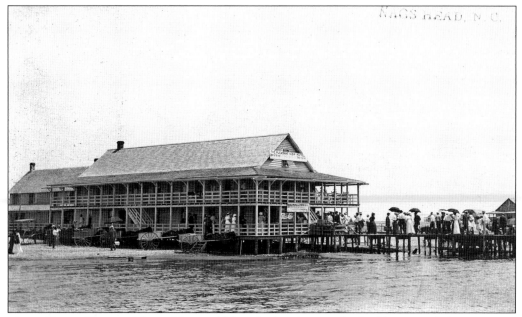

NAGS HEAD HOTEL, NAGS HEAD. Although the sign on the building says "Pleasant View Hotel," this was best known as the Nags Head and sometimes referred to as Lowe's because its last owner was John Lowe. The three-story hotel, built before 1893, had 100 guest rooms. It was destroyed by fire in 1903. The photo may be from the late 1890s. (From the collections of the Outer Banks History Center, *c.* 1910.)

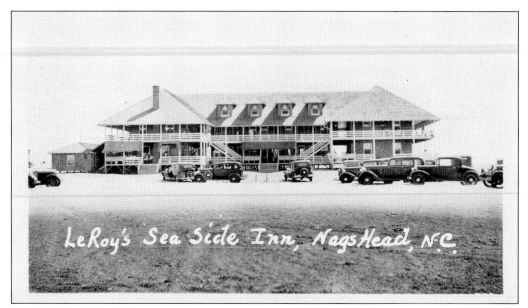

LEROY'S SEASIDE INN, NAGS HEAD. Henry and Marie LeRoy started their hospitality business with the soundside LeRoy Hotel. When it was destroyed in the same storm that claimed Albemarle Cottage, they built the 50-room Seaside Inn. In 1937, it was sold and renamed the First Colony Inn. In 1988, it was moved to the west side of the beach road, three-and-a-half miles from its original oceanfront location. (Courtesy of Michael G. Tames, 1930s.)

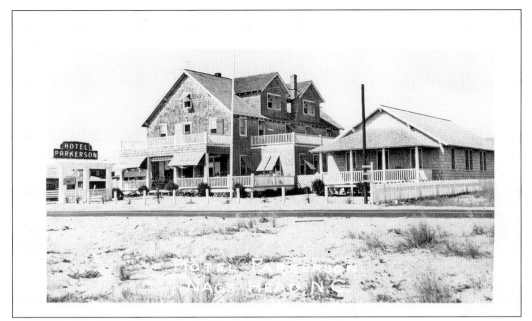

HOTEL PARKERSON, KILL DEVIL HILLS. This was one of several early oceanfront hotels built south of the Wright monument in the 1930s. Neither the town nor the Kill Devil Hills Post Office existed yet; all advertisements for the hotel used Nags Head as its address. (Courtesy of Willard E. Jones, 1933.)

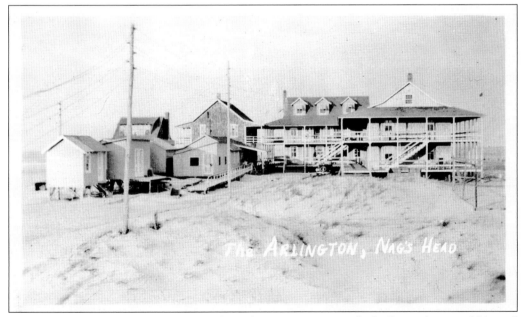

ARLINGTON HOTEL, NAGS HEAD. The Arlington was originally built on the soundside and operated as Modlin's Hotel. Dewey and Phoebe Hayman bought it in 1944, after it was moved to the oceanfront, and they soon built a reputation for gracious hospitality. The hotel was considered an Outer Banks landmark until 1973 when storm tides knocked it into the Atlantic. (Courtesy of Michael G. Tames, 1938.)

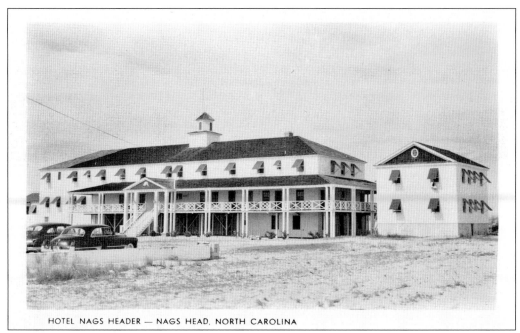

HOTEL NAGS HEADER — NAGS HEAD, NORTH CAROLINA

HOTEL NAGS HEADER, NAGS HEAD. The three-story oceanfront hotel was built in 1935 at milepost 11. Every room had its own bath with hot and cold running water—amenities that made it luxurious for its day. A fire destroyed it in 1978. (Courtesy of Michael G. Tames, 1940s.)

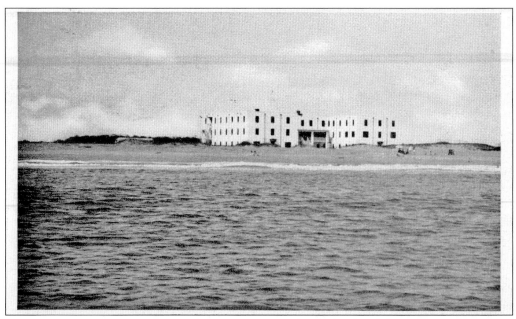

CAROLINIAN HOTEL, NAGS HEAD. The large stucco building was an imposing addition to a nearly empty oceanfront when it opened in 1947 at milepost 10. In its heyday in the early 1960s, the hotel's knotty-pine lobby, with a moose head over the brick fireplace, was the social center of the beach. The building was torn down in 2001 to make room for new beach cottages. (Courtesy of Michael G. Tames, 1952.)

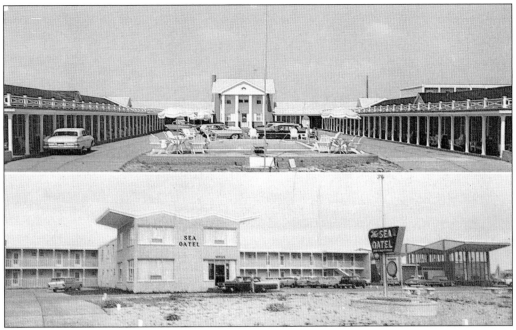

SEA OATEL, NAGS HEAD. Located at the 16.5 milepost, this motel has undergone several facelifts over the last 40 years. It lost its Dareolina Restaurant years ago, but the Sea Oatel lives on. (Courtesy of Michael G. Tames, 1962.)

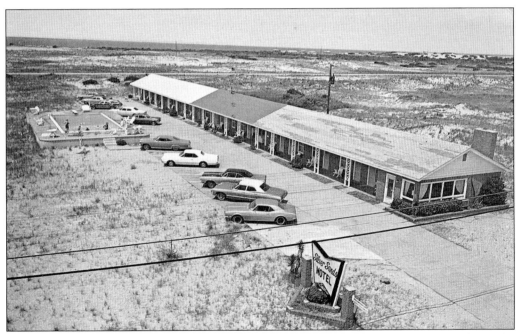

SILVER SANDS MOTEL, NAGS HEAD. One of the few motels not built on the oceanfront, the motel sat in near isolation for several years after it was built near milepost 14 in the 1960s. Surrounded by houses and other businesses by 2002, it was sold and torn down to make way for a real estate office and more houses. (Courtesy of Michael G. Tames, 1970.)

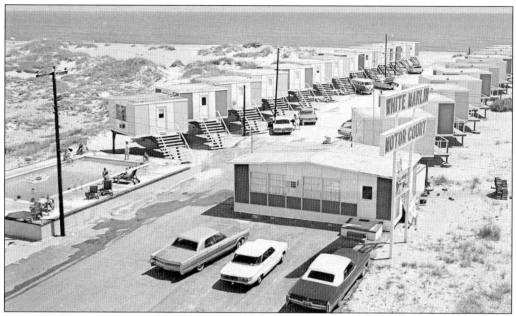

WHITE MARLIN MOTOR COURT, NAGS HEAD. Long gone, these modular efficiencies were high tech in the 1960s, when this motel was built south of Whalebone Junction on Old Oregon Inlet Road. The air-conditioned units came fully furnished with dishes, pots and pans, and linens, as did the efficiencies rented by other Outer Banks motels. (Courtesy of Michael G. Tames, 1960s.)

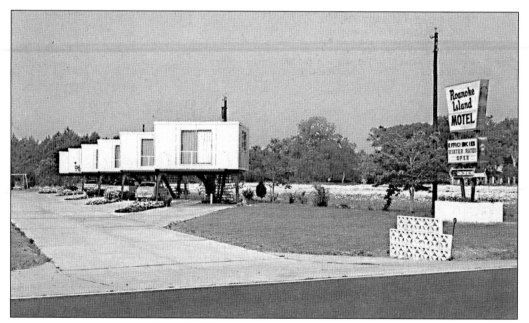

ROANOKE ISLAND MOTEL, ROANOKE ISLAND. Raised high enough to offer covered parking, these units on Roanoke Island were billed as "Weekender Efficiencies." Locals insist that, when the motel closed, the rooms-in-a-box were trucked off to another life—possibly in Colington or on Hatteras Island. (From the collections of the Outer Banks History Center, 1960s.)

TRANQUIL HOUSE, MANTEO. Asa and Celia Evans bought and enlarged an existing boardinghouse to open Tranquil House as a hotel in 1885. It was bought by Nathaniel and Lizzie Gould in 1917 and operated until 1959. In the 1980s, the name was borrowed for a new inn, built on the Manteo waterfront across the street from where the old Tranquil House once sat. (Courtesy of Willard E. Jones, date unknown.)

MANTEO MOTEL, MANTEO. Roanoke Island's first modern motel was opened in 1954 by Rev. Earl Meekins, whose family managed the business until it was sold in 2002. The motel already had air conditioning and heat, televisions, and private phones when it was renamed the Elizabethan Inn and Tudor embellishments were added to the facade in the 1960s. (From the collections of the Outer Banks History Center, *c.* 1958.)

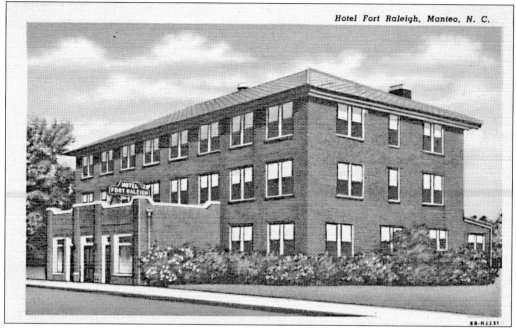

Hotel Fort Raleigh, Manteo, N. C.

HOTEL FORT RALEIGH, MANTEO. When the brick hotel was built on Budleigh Street about 1930, it was the grandest on Roanoke Island. The building is now used for Dare County offices. (Courtesy of Michael G. Tames, *c.* 1937.)

Dining Room--Fort Raleigh Hotel

A Typical Guest Room--Fort Raleigh Hotel

HOTEL FORT RALEIGH, MANTEO. An advertisement for the new hotel promised "modern plumbing, heating and the luxurious appointments of a city hotel." Rooms with the guest's choice of American or European plan started at $1.50 a night. (From the collections of the Outer Banks History Center, *c.* 1930.)

CAPE HATTERAS NATIONAL SEASHORE, BUXTON. Not everyone who comes to the Outer Banks wants to sleep indoors. Campgrounds within the Cape Hatteras National Seashore stay busy throughout the warm-weather months. (Courtesy of Michael G Tames, date unknown.)

HOTEL ATLANTIC VIEW, HATTERAS. Half of this two-story, frame hotel—the first on Hatteras Island—was built in 1928. The building was doubled in size by 1950. New owners refurbished the building, renaming it the Seaside Inn Bed & Breakfast, in 2002. Hurricane Isabel heavily damaged the building in 2003. (From the collections of the Outer Banks History Center, *c.* 1950.)

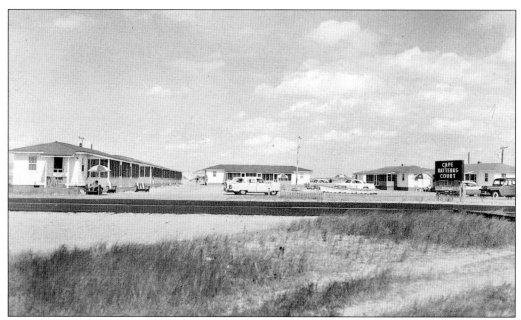

CAPE HATTERAS COURT, BUXTON. This was one of the first motels in Buxton. Shortly after it was built in the early 1950s, advertisements claimed its rooms were 300 feet from the ocean. By the 1990s, beach erosion had put the ocean at its doorstep. Rebuilding has kept the Cape Hatteras modernized and in business. (Courtesy of Michael G. Tames, *c.* 1960.)

OUTER BANKS MOTEL, BUXTON. The comforts and conveniences of home were what guests wanted—and got—back in the late 1950s, when this photograph was probably taken. Located next door to the Cape Hatteras on the same narrow stretch of beach, the Outer Banks Motel has also had to reinvent itself to keep its doors open. (Courtesy of Michael G. Tames, *c.* 1960.)

BEACON MOTEL, HATTERAS. Willie Newsome opened this motel next door to his sport fishing center to provide everything the sportsman needed. Guests could get a room, rent their tackle, buy their bait and a cold beverage, and book a deep-sea fishing trip with one stop. Damaged in Hurricane Isabel, the motel was torn down in 2003. (Courtesy of Michael G. Tames, 1960s.)

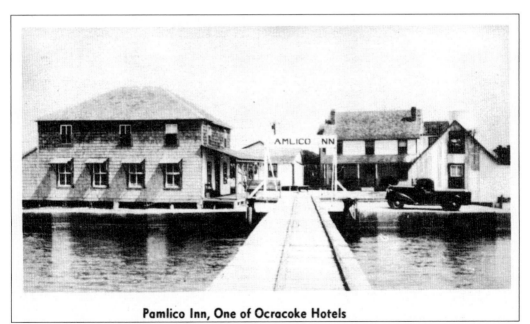

PAMLICO INN, OCRACOKE. Ocracoke, like Nags Head, was a popular port of call for steamships in the 1800s and early 1900s. This is one of several hotels that catered to summer guests. The hotel was destroyed in a 1944 hurricane. (Courtesy of Willard E. Jones, c. 1940.)

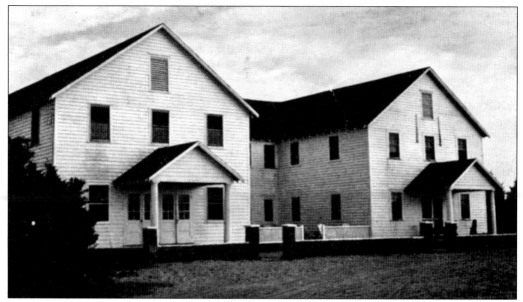

WAHAB VILLAGE HOTEL, OCRACOKE. Opened in 1939, this hotel—still in use as part of Blackbeard's Lodge—has led a colorful life. For several years, the island's only movie theater operated on the premises. There was a short-lived skating rink inside and a dining room, and it served as housing for navy officers during World War II. (From the collections of the Outer Banks History Center, *c.* 1940s.)

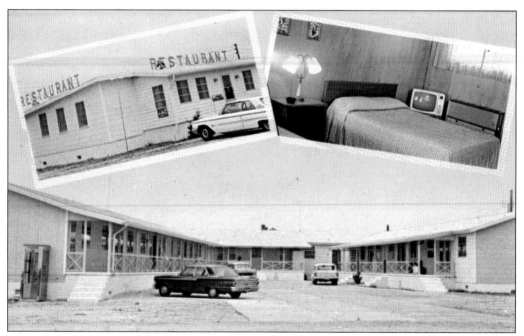

PONY ISLAND MOTEL, OCRACOKE. Built after World War II, in part with cinderblocks from the old navy base, the Pony Island Motel and its adjacent restaurant have become island landmarks. Thoroughly modern now, the original building is still in use. (Courtesy of Michael G. Tames, 1960s.)

Ten

OUTER BANKS STYLE

When summer visitors first began coming to the Outer Banks in the 1800s, they were coming to escape "the summer diseases of our climate," as one advertisement for Nags Head from that era put it. Guests were promised "Sea air, bathing and exercise, with a constant supply of the finest fish, oysters, and crabs." Medical knowledge being what it was at the time, these were practical enticements.

A few years later, hotel owners were still relying on the area's natural resources to satisfy their guests. Cottage families enjoyed the same entertainments. One could take cart rides through Nags Head Woods, go fishing at the fresh ponds, ride to the ocean in a rail car for a day of "bathing" (swimming in the ocean was, at that time, considered exotic), or hike up Jockey's Ridge with a box lunch. People strolled, sketched, wrote poetry, and kept journals to occupy their free time. Evenings were a time of social interaction, music, and dancing.

All the summer people arrived by boat. In addition to the private boats that brought many cottage owners, two or three large steamboats and a number of smaller vessels brought dozens of visitors to Nags Head every week. Some came for the day from Manteo and Elizabeth City; others came farther, through ports in Norfolk or New Bern, to stay for the week, the month, or, quite often, the entire season. Keeping them all fed and entertained, their rooms cleaned, and their laundry washed and pressed required a lot of local help. Summer visitors were clearly good for Nags Head's economy.

By the early 1920s, the automobile was becoming the transportation of choice for Americans on the mainland. People wanted to drive their cars to their vacation places. And as the economy changed, the era of the summer-long vacations died.

About this time, a few farsighted leaders in the community—including Frank Stick, W.O. Saunders, and Washington Baum—began to see that tourism was the barrier islands' destiny. They realized that roads and bridges would be the key, both for bringing visitors to the Outer Banks and for growing the local economy. They realized, too, that great beaches and scenery along with reasonably pleasant weather and good fishing were just starting points. The Outer Banks' best shot at becoming a vacation destination was to capitalize on its unique history. The building of the Wright Brothers National Monument, developing Fort Raleigh and The Lost Colony outdoor drama, and creating the Cape Hatteras National Seashore all grew out of deliberate efforts to preserve the heritage of the area while encouraging visitors to come enjoy it.

The first project tackled was the Wright memorial. In 1925, with the 25th anniversary of flight approaching, community leaders pushed hard to get congressional approval and funding for some sort of

commemorative monument. Once the project was approved, the state, which had been reluctant to fund roads in the area, was pressured into improving access to the federal site. In 1932, the monument was finally completed.

Establishing the Cape Hatteras National Seashore took even longer. First proposed in 1933, the initial legislation to create the recreation area was passed by Congress in 1937, although all land had to be donated and no funds to administer it were appropriated until 1953. The national seashore, America's first, was dedicated in 1958, ensuring that thousands of acres of barrier island would remain undeveloped.

Shortly after the Wright monument was complete, area leaders began lobbying for the restoration of Fort Raleigh on Roanoke Island. The Works Progress Administration committed funds for a variety of projects on the Outer Banks, including the restoration work and a 3,000-seat outdoor amphitheater. The first production of The Lost Colony—one of Saunders's many ideas—was staged at the new facility in 1937.

Jockey's Ridge, the state's largest natural dune, was purchased and established as a state park in 1975, after development plans threatened to flatten it.

What is now the North Carolina Aquarium on Roanoke Island opened in the 1970s as one of three North Carolina Marine Resources Centers.

In 1978, planning began for the celebration of the 400th anniversary of the Roanoke Voyages. This included building the Elizabeth II, a representative 16th-century sailing ship, and placing her at the Elizabeth II State Historic Site on Ice Plant Island, now Roanoke Island Festival Park.

Diversity is an important part of the Outer Banks' long-term success as a vacation destination. The Outer Banks experience is not just about beaches and history, fishing, shopping, or any of the dozens of other indoor and outdoor activities available every day. It is not just about finding a comfortable place to stay, good places to eat, and the hospitality that makes a person want to come back. It is the sum of all these things that sets the stage for people to relax, set their workaday worlds aside, and enjoy each other's company. That is a vacation Outer Banks style.

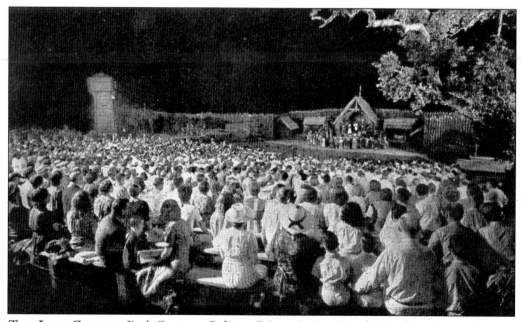

THE LOST COLONY. Paul Green, a Pulitzer Prize–winning North Carolina playwright, was recruited to write a pageant commemorating the 350th anniversary of the birth of Virginia Dare, the first English child born in the New World, in 1937. His script became the basis for what is now the longest-running outdoor drama in America. It is performed at Fort Raleigh every summer. (From the collections of the Outer Banks History Center, 1940.)

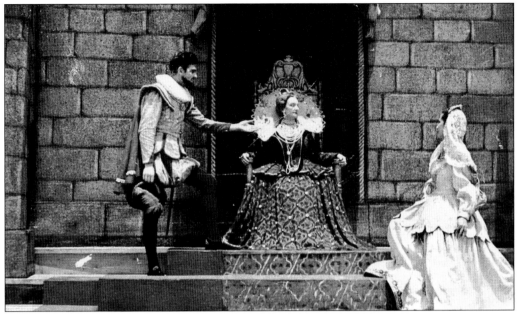

THE LOST COLONY. Andy Griffith joined *The Lost Colony* in 1947 and appeared in other roles before being cast as Sir Walter Raleigh in the 1953 production of the play. In this photograph, Griffith, as Raleigh, urges Queen Elizabeth, played by Lillian Prince, to allow ships to leave for his colony at Roanoke Island. (From the collections of the Outer Banks History Center, *c.* 1953.)

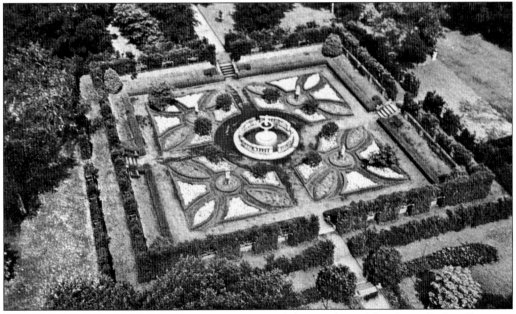

ELIZABETHAN GARDENS. The garden, a project of the Garden Club of North Carolina, was established on a 10-acre tract next to Fort Raleigh in the early 1950s to memorialize Roanoke Island's 1587 colony. Designed by New York landscape architects Richard Webel and Umberto Innocenti, the year-round garden includes more than a dozen pieces of 16th-century Italian sculpture. (Courtesy of Michael G. Tames, 1975.)

ENTRANCE TO OLD FORT RALEIGH
Roanoke Island, N. C.

ENTRANCE TO FORT RALEIGH. In the late 1800s, efforts were made to preserve the history of the Roanoke colonies. Historical markers and annual celebrations of Virginia Dare's birthday kept the story alive. Actual reconstruction at the site was started in the 1930s with WPA funds earmarked for historic restoration. This palisade entrance was completed in 1934. (Courtesy of Michael G. Tames, *c.* 1940.)

FORT RALEIGH CHAPEL
Roanoke Island, N.C.

CHAPEL AT FORT RALEIGH. Several buildings were constructed during the WPA program, including this chapel designed by Frank Stick, an artist and outdoorsman from New Jersey who relocated to the Outer Banks in the 1920s. All were torn down after the National Park Service took over the site in 1941, because the historical accuracy of their construction was uncertain. (From the collections of the Outer Banks History Center, *c.* 1940.)

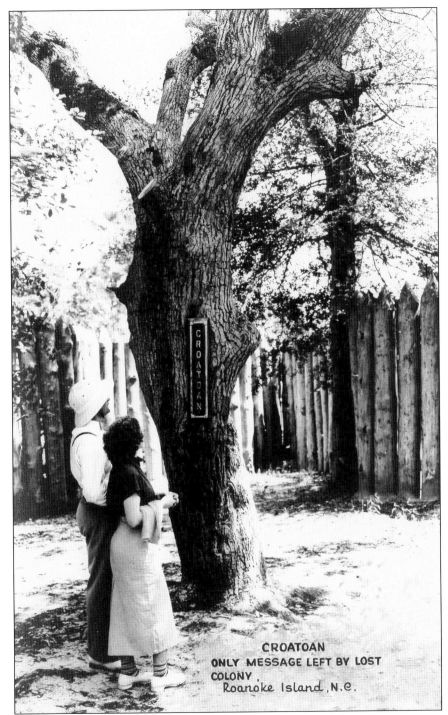

FORT RALEIGH. When John White, governor of the Roanoke Colony, returned some three years after leaving his colonists short of food and on poor terms with the local natives, he reported finding the letters CRO carved in a tree near the fort. This historically inaccurate re-creation is from the 1930s. (From the collections of the Outer Banks History Center, *c.* 1940.)

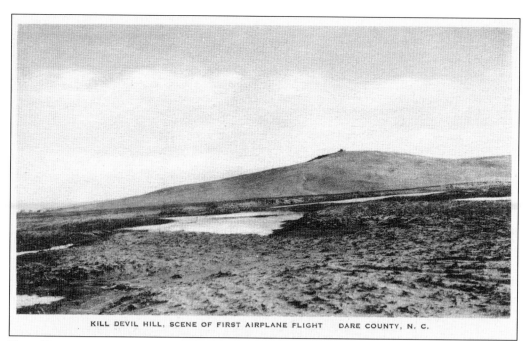

KILL DEVIL HILL, SCENE OF FIRST AIRPLANE FLIGHT DARE COUNTY, N. C.

KILL DEVIL HILL. Legislation authorizing the Kill Devil Hill Memorial, later renamed the Wright Brothers National Monument, was passed in 1927. Organizers hoped to dedicate a completed monument to celebrate the 25th anniversary of the first flights in 1928. Instead, a cornerstone, visible at the top of the hill, was laid; the monument was not finished until 1932. (From the collections of the Outer Banks History Center, *c.* 1928.)

WRIGHT BROTHERS NATIONAL MONUMENT. Construction of the 61-foot granite tower included stabilizing the sand dune, which had been migrating steadily to the southwest. It took a crew of up to 60 men, supervised by a New York contractor, one year to build the monument. Orville Wright attended the dedication ceremony; Wilbur had died 20 years earlier. (Courtesy of Michael G. Tames, date unknown.)

114

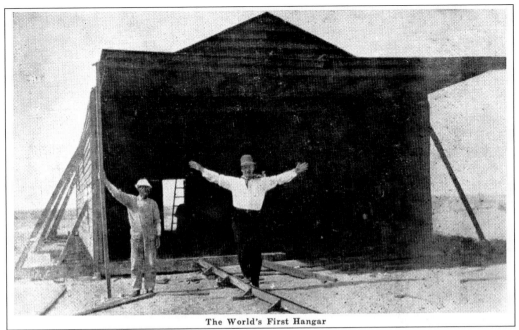

The World's First Hangar

THE FIRST AIRPLANE HANGAR. This postcard may have been made from a photograph taken by the Wrights at their Kill Devil Hill camp in 1902. The hangar, built in 1901, housed the 1902 glider, while the Wrights lived in a tent. They later built a second hanger that included a kitchen and a loft for sleeping. (From the collections of the Outer Banks History Center, date unknown.)

WRIGHT BROTHERS NATIONAL MEMORIAL. In 1928, Orville chose this spot to place the commemorative boulder marking where the 1903 flyer took off. The striking architecture of the new visitor's center, opened in 1960, is visible in the background. (From the collections of the Outer Banks History Center, *c.* 1960.)

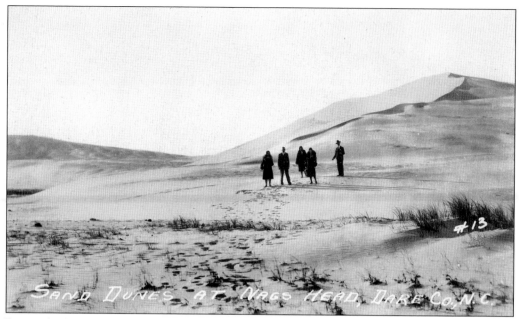

JOCKEY'S RIDGE. What was once the East Coast's largest sand dune had been a noted landmark for hundreds of years along the coast. Generations of locals and visitors climbed to its top, slid down its flanks, and used it as a picnic spot, for a romantic rendezvous, and, as local legends have it, a viewing platform for horse races. (Courtesy of Michael G. Tames, *c.* 1930.)

HANG GLIDING AT JOCKEY'S RIDGE. When developers began bulldozing the dune in the early 1970s, locals were surprised to learn this beloved landmark was private, not public, property. Preservation efforts were successful, a state park was established, and one of the nation's first hang-gliding schools began operation there. As the Wrights had discovered nearby, a barrier-island sand dune is a good place to practice gliding. (Courtesy of Michael G. Tames, *c.* 1976.)

116

COQUINA BEACH. This was the first developed beach within the Cape Hatteras National Seashore. Located on the southern border of Nags Head at Bodie Island, the visitor's center included a bathhouse and sun–screened picnic tables. Built in the mid-1950s, its buildings were painted in orange, turquoise, and other stylish colors. (From the collections of the Outer Banks History Center, 1961.)

OCRACOKE VISITOR'S CENTER. The National Park Service acquired most of Ocracoke Island in 1953 for the Cape Hatteras National Seashore. After a paved road was built from the ferry docks in 1957, a visitor's center was opened on Silver Lake in the village. The old navy building, used by the park service until the 1980s, had once been a torpedo shed. (Courtesy of Michael G. Tames, 1966.)

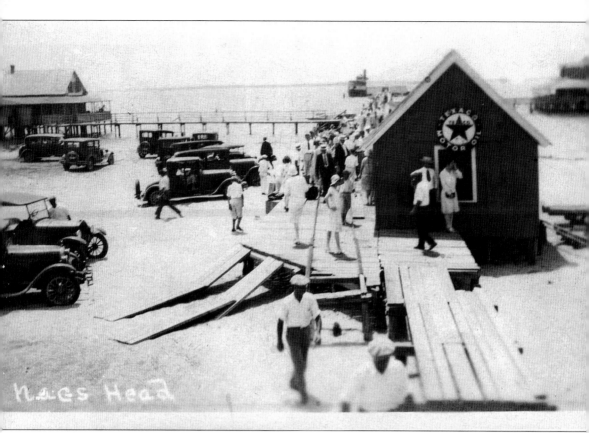

NAGS HEAD SOUNDSIDE. Two eras intersect on this sunny day at the beach, as crowds pour off the excursion ship docked at the end of the pier while automobiles pack the shoreline. (Courtesy of Willard Jones, *c.* 1930.)

NAGS HEAD OCEANSIDE. By the 1930s, more visitors were staying on the oceanfront. As swimming in the ocean became a popular recreation, swimsuits became more daring. But even in earlier times, guests who stayed soundside could take motor trams or mule-drawn carts to the beach, where bathhouses were open for changing. (Courtesy of Michael G. Tames, 1930s.)

NAGS HEAD OCEANSIDE. No matter the year, more visitors come to the Outer Banks to enjoy the beach than for any other reason. (From the collections of the Outer Banks History Center, date unknown.)

SURFING. Since the 1960s, the Outer Banks has been an East Coast surfing destination. East Coast Surfing Association championships are held on Hatteras Island every year. (From the collections of the Outer Banks History Center, 1966.)

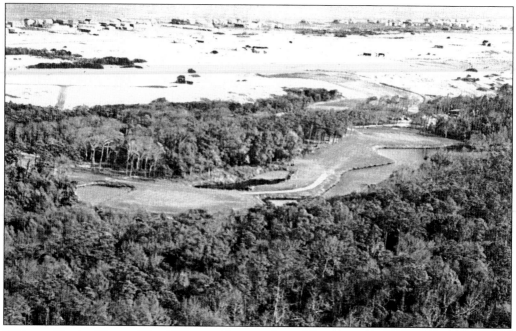

GOLF IN KITTY HAWK. The 1990s saw the greening of the Outer Banks, with the addition of several new golf courses on and near the barrier islands. Sea Scape, a public course, opened in 1965. Built shortly after Duck Woods, a private course in Southern Shores, Sea Scape has several holes that offer expansive ocean views. (From the collections of the Outer Banks History Center, *c.* 1966.)

GOLF ON ROANOKE ISLAND. Around the time Duck Woods and Sea Scape golf courses were built, a small course and driving range opened north of Manteo near Fort Raleigh. The land it occupied is now a housing development. (Courtesy of Michael G. Tames, 1966.)

NAGS HEAD CASINO. In 1931, Moncie Daniels bought a building at milepost 13 on the west side of the beach road and opened a dance hall. In 1937, it was sold to Ras Wescott. For years, the casino was the center of nightlife for locals and visitors. Music and barefoot dancing were its claims to fame, but it was also a bowling alley, boxing ring, and bar. The building collapsed during a nor'easter in 1976. (Courtesy of Michael G. Tames, 1960s.)

NAGS HEAD SUPERMARKET. Before the days of Food Lion, this was the largest supermarket on the beach. It was later known as Bell's General Store. Located around milepost 11 of the beach road, part of the building was torn down in the 1980s and replaced with condominiums; part still survives as Don Gatos restaurant. (From the collections of the Outer Banks History Center, *c.* 1960.)

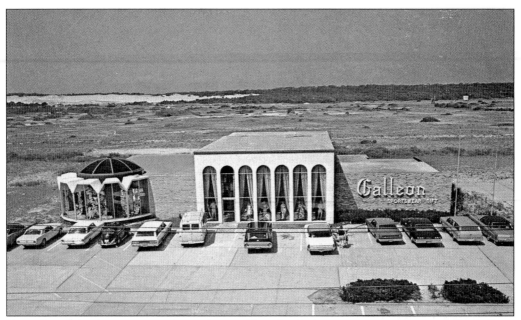

THE GALLEON ESPLANADE, NAGS HEAD. What the Casino was to entertainment, the Galleon was to shopping. This extravaganza of stucco, brick, and, at a later time, a geodesic dome, was the brainchild of George Crocker. Crocker, who owned two nearby motels, sold out in the 1980s. In the 1990s, the shopping oasis was torn down and replaced with houses. (From the collections of the Outer Banks History Center, date unknown.)

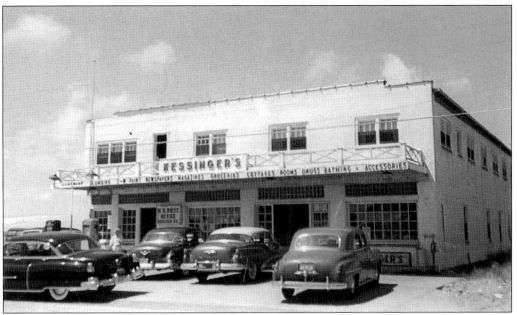

KESSINGER'S, NAGS HEAD. The general store on the beach road across from Cottage Row opened in 1938. Owner Roy Kessinger became the postmaster and ran the post office out of his shop until a new post office building was built next door. The old store was torn down. (Courtesy of Michael G. Tames, 1959.)

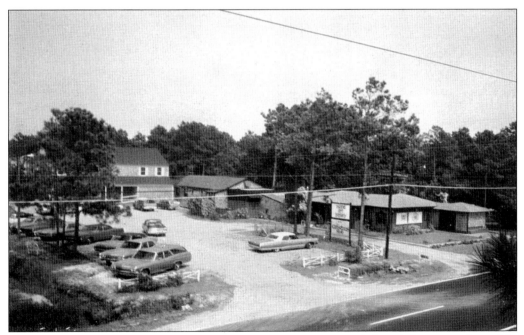

THE ISLAND ART GALLERY AND CHRISTMAS SHOP, MANTEO. Edward Greene performed in *The Lost Colony* as a dancer in the 1950s and then returned to Roanoke Island ten years later to open one of the country's first year-round Christmas stores. He is still spreading the sparkle. (Courtesy of Michael G. Tames, 1972.)

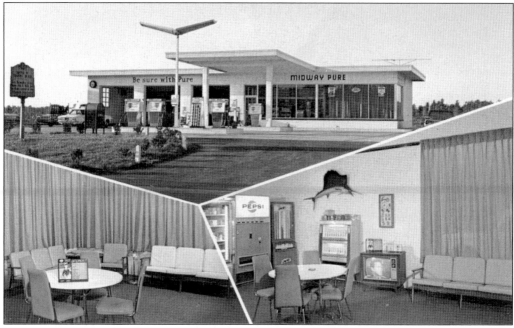

MIDWAY GAS STATION, ROANOKE ISLAND. Located at the intersection of the Manteo-Wanchese highway and the Manteo–Nags Head causeway, this gas station set a new standard for service. Open 24 hours a day, it had a lounge and offered customers free color television, coffee, and their choice of a bath or shower. (From the collections of the Outer Banks History Center, 1960s.)

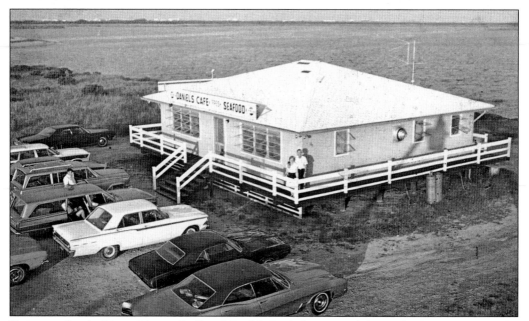

DANIELS CAFÉ, NAGS HEAD. Basil and Beulah Daniels operated this seafood restaurant on the causeway for about five years. After they sold it, the new owners continued using the Daniels name. It was located where Basnight's Lone Cedar Restaurant now sits. (Courtesy of Willard E. Jones, 1970.)

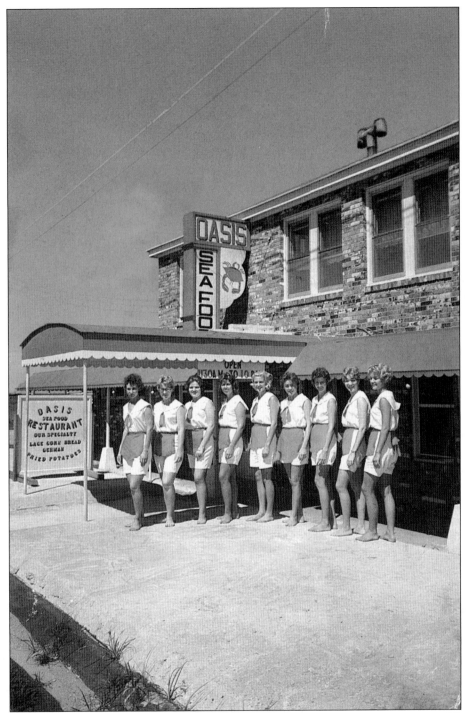

THE OASIS, NAGS HEAD. An Outer Banks institution for years, this restaurant, owned by the Kellam family, was as well known for its barefoot waitresses as for its signature lace cornbread. It was later sold, reacquired by the Kellam family, and sold again before it burned down in 2004. (Courtesy of Michael G. Tames, 1970.)

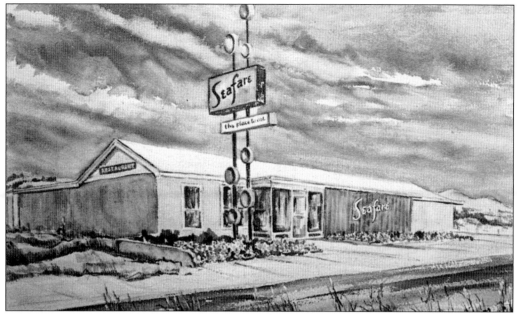

SEAFARE, NAGS HEAD. Michael Hayman capitalized on his family's reputation at their Arlington Hotel to build a loyal following at this classic Nags Head dining spot. The Seafare's legacy is the impressive list of successful Outer Banks restaurant owners and managers who started their careers under Hayman's tutelage. (Courtesy of Michael G. Tames, 1964.)

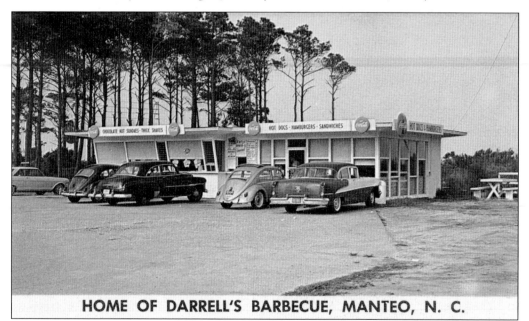

THE POLAR BEAR DRIVE-IN, MANTEO. In 1960, Darrell Daniels opened his drive-in with a menu of standard drive-in fare plus "Darrell's barbecue." In 1972, when he was ready to take the restaurant to the next level of service—sit-down dining—Darrell's was the obvious name choice. The building has been remodeled and expanded, but it is still in use. (Courtesy of Willard E. Jones, 1960s.)

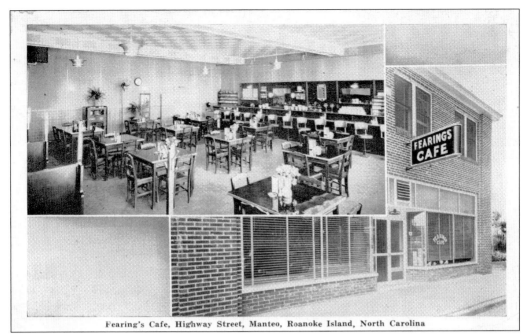

Fearing's Cafe, Highway Street, Manteo, Roanoke Island, North Carolina

FEARING'S CAFÉ, MANTEO. The Fearing family has owned several downtown businesses, including this café on what is now Budleigh Street. Over the years, a Fearing drugstore, soda fountain, dress and gift shops, and a hardware store occupied two buildings in this block. One of the buildings burned in 1981, but the one shown on this postcard is still used as retail space. (Courtesy of Michael G. Tames, 1942.)

HATTERAS ISLAND DRIVE-IN. The first drive-in restaurant on Hatteras Island was on Highway 12, near the fishing pier in Rodanthe. By 1980, it was gone. In 2004, the Pamlico Station shops are located where the drive-in once stood. (Courtesy of Michael G. Tames, 1960s.)

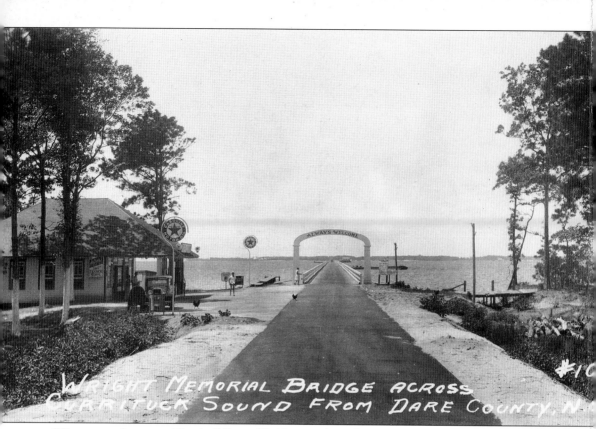

WRIGHT MEMORIAL BRIDGE ACROSS CURRITUCK SOUND FROM DARE COUNTY, N

WELCOME ALWAYS. The building of bridges and roads connecting the Outer Banks to the mainland brought gas stations, motor courts, and, of course, more people to the barrier islands. Hospitality was already in place, as the Wright brothers and other early visitors could attest. But with a paved connection to the outside world, tourism and its closely related cousin, real estate, began to displace fishing, farming, and federal service as the area's primary businesses. Community leaders with vision saw the future—and it was sharing the beauty and history of their islands with others.